The Fundamentals of Creative Photography
David Präkel

An AVA Book

Published by AVA Publishing SA
Rue des Fontenailles 16
Case Postale
1000 Lausanne 6
Switzerland
Tel: +41 786 005 109
Email: enquiries@avabooks.com

Distributed by Thames & Hudson
(ex-North America)
181a High Holborn
London WC1V 7QX
United Kingdom
Tel: +44 20 7845 5000
Fax: +44 20 7845 5055
Email: sales@thameshudson.co.uk
www.thamesandhudson.com

Distributed in the USA & Canada by:
Ingram Publisher Services Inc.
1 Ingram Blvd.
La Vergne TN 37086
USA
Tel: +1 866 400 5351
Fax: +1 800 838 1149
Email: customer.service@
ingrampublisherservices.com

English Language Support Office
AVA Publishing (UK) Ltd.
Tel: +44 1903 204 455
Email: enquiries@avabooks.com

© AVA Publishing SA 2010

ISBN 978-2-940411-13-9

10 9 8 7 6 5 4 3 2 1

Design by William Southward
Cover image by Lincoln Luke Chanis

Production by AVA Book Production Pte.
Ltd., Singapore
Tel: +65 6334 8173
Fax: +65 6259 9830
Email: production@avabooks.com.sg

David Präkel

The Fundamentals
of Creative
Photography

Ethical: aware-
ness/
reflect-
ion/
debate

1

Photographic fundamentals
010

2

Communication
036

3

Applied photography
062

Contents
004

Introduction
006

4

Professionalism
112

5

The brief
136

6

Workflow
166

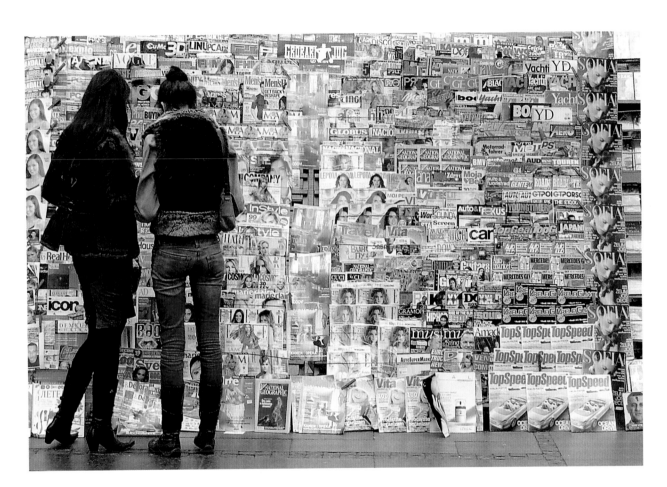

Untitled
Greg Chandler

Every image on this magazine
stand will either have come from
an image library or will have
been specifically created to
commission. Photographers
create images for a wide variety
of media.

Photography is a form of artistic self-expression. For many photographers, that is where the subject begins and ends. Their aim is to refine a personal vision, whatever the subject - to create the most beautiful, the most moving, or the most communicative image possible. Goals are entirely self-set. Rewards - disregarding photographic competitions - are personal satisfaction and possibly acclaim. However, today's image-saturated world is full of photographs created with quite a different motivation. This photography is not a matter of self-expression. The majority of those engaged in photography as a profession are involved in this process - the creation of images intentionally for the use of others. Creativity is at a premium as only unique and striking images will rise to the surface of the image-mass and be memorable, but this is individual creativity used on behalf of others.

An all-encompassing title to describe this type of photography is difficult to find. An earlier generation of readers would have recognised and understood the phrase 'applied photography'. Nowadays, this phrase is too limited to accurately express and encompass what modern image-making and image use is all about. Applied photography also has connotations of scientific imaging and imagery that is purely of record, which most certainly is not what this book is about. The word 'applied', however, could also mean the use of creative photographic images for some other purpose - usually with a commercial context, though not necessarily so. We are choosing to call this 'creative' photography.

The Fundamentals of Creative Photography has to start with an understanding of the fundamental principles of photographic technique, and the formal elements of composition and design. From the outset, this book takes the view that photography is a language with a vocabulary and grammar, and that the modern photographer must become fluent in this language to understand the client's requirements, and to create imagery that is both expressive and communicative to the viewer. Chapter 1 of the book looks closely at how technical aspects of photography can be used expressively and with intent.

Communication is the key to successful creative photography. The second chapter looks at visual literacy, the owners and users of an image, and how they influence its content. Using carefully selected examples, the reader will be shown how to take apart - deconstruct - an image to read its meaning, and to understand the photographer's intent and the image's purpose and message. This section will also provide an easily understood introduction to semiotics - the study of signs. It will, in addition, look at influences and context. A vital part of working in the creative imaging industries is being able to describe accurately and succinctly what you see or what you intend to create. The chapter concludes with a look at how technical, artistic and emotional language can be used with precision.

So where could you consider employment within the creative industries? The third chapter looks at various sectors of the creative photographic industry including image making for advertising and commercial concerns - the similarities and differences in taking photographs for publication. Fashion photography is one of the most sought after professions, but is also one of the hardest to enter. Though for many areas of creative photography the client will be a brand, an organisation or publication, there is some paid-for creative work done for individuals. Social photography - privately commissioned portraits of individuals, families and groups - involves a different form of client relationship. Usually, this is on a one-to-one basis that suits some photographers, but not others. News gathering and photojournalism, too, are not for every photographer. There are also many roles in the industry where you will not be working as an active image-maker, but dealing with imagery in the context of a gallery or stock library. These closely connected roles, which require a full understanding of the creative photographic process, are also discussed.

To take part in the creative industries usually means having a commercial and therefore professional involvement. Chapter 4 looks closely at how to develop a professional approach, how to get an appropriate education and how to gain experience. You will need to market and promote your talents to win work and this chapter explains how to create a portfolio (hard copy or web based) that will send out the right messages and bring in the right kinds of offers. Once you are established it may be important to join a professional body or to employ an agent to represent you and negotiate on your behalf with clients.

In creative photography, the client calls the shots. However, you need to understand what they require of you and what you can do for them. Chapter 5 looks at the brief. This can be a formal or informal agreement - a shared understanding between client and photographer. It covers important issues such as how far you can take your creativity; how to present the finished job in a proper format; and how to deal with legal and contractual issues. This section also looks at how to work with others and how to work safely.

Understanding the photographic workflow is key to understanding image-making in the creative industries. The final chapter of the book explains the basic workflow, from the 'pre-shoot' planning to asset management. Through the use of case studies, it will look at very different applications of the basic workflow specific to different sectors.

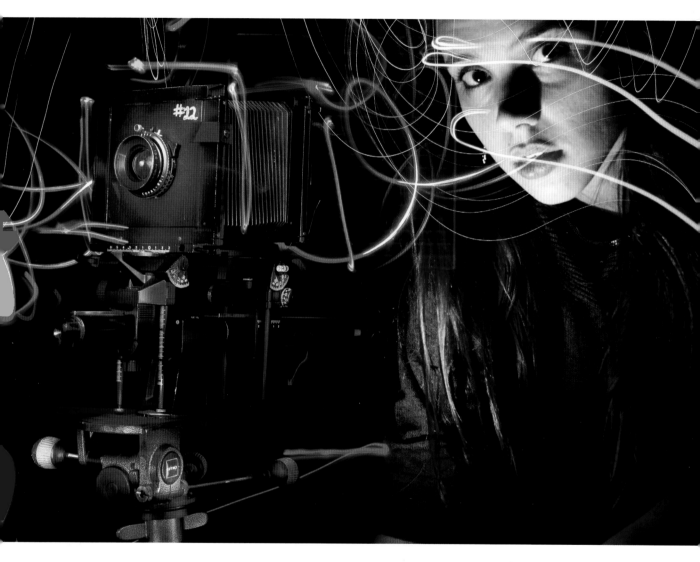

View camera
Michelle Wood

A college or university education in photography gives you room to develop your creativity; master a range of professional equipment and try different styles and techniques.

1

2

Photographic fundamentals

Photographic (adj.) relating to photography

Fundamentals (n.) guiding or essential
principles on which something is based

Communication

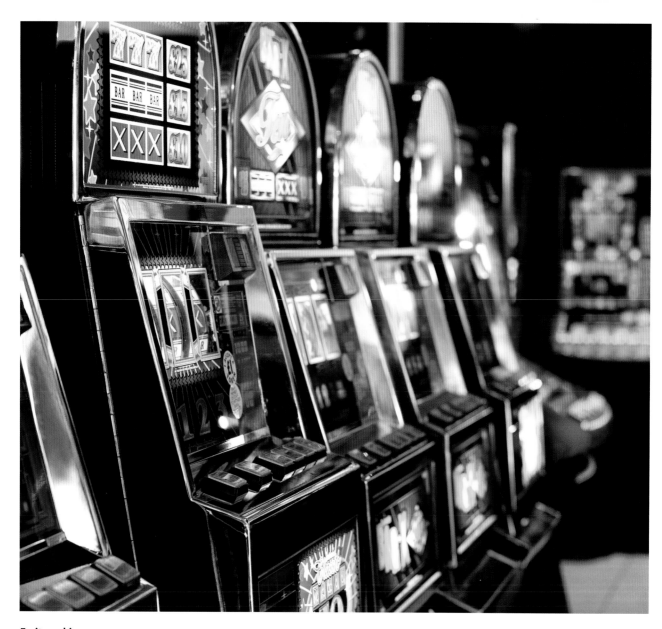

**Fruit machines
Phil Barton,
Laurence Hudghton
Photography**

A creative photographer
will always make more
of an image using camera
technique – controlling
depth of field, for example,
as shown here.

The world is saturated with images, most of them photographic or in some way based on photography. Although we take it for granted, photography mediates our understanding of the visual world – it is pervasive and unstoppable. Society seems to be suffering from image overload. We certainly recognise photography when we see it. Photography was once thought of as a medium of record, but some would say its boundaries of truth are now becoming increasingly blurred. We need to ask at the outset: just what is photography?

We could just as easily be talking about heliography. That was the name given to the first permanent images from nature, produced in and around 1826, by a Frenchman named Joseph Nicéphore Niépce. He called his creations 'heliographs' from the Greek words for 'sun' and 'writing/drawing'. There was then no universally accepted word for the process of making images with light. In England, William Henry Fox Talbot referred to his process - unlike those of Niépce and later Daguerre - as photogenic drawing - quite literally drawings generated by light.

In 1839, as the photographic process was being announced to both the public and scientific communities in England and France, the astronomer royal and friend of Fox Talbot - Sir John Herschel - suggested the word 'photography'. This too is a compound of the classical Greek words for light and the act of drawing or writing: *photos* and *graphien*.

So photography is about images made by light. That includes - but is not restricted to - images made with lenses, which is why there is a category today in arts and education labelled 'lens-based media'. Now that we know what photography is, we need to ask: what does society use photography for? Again, there are almost as many answers to that question as there are people you can ask. Answers, however, will be clustered around various topics such as: for sharing, to remember an emotion, to put over an idea, or to draw people's attention to a situation.

We have now agreed what photography is and what we use it for. To be able to create our own quality images we need to know what makes a good photograph. Asking people what they think makes a good photograph generates many answers. Ask enough people and their answers will fall into two distinct categories.

One category focuses on the technical aspects of an image - exposure, use of photographic techniques, etc. The other category is harder to define - some would say it relates to the artistic aspects of the image. Putting the words 'art' and 'photography' in the same sentence immediately opens up a whole series of other questions, so let us call this other category things to do with the 'composition' of the photograph. Instead of talking about good photography I would borrow the definition used by the photojournalist Andreas Feininger (1906-1999) who described it as *effective* photography - a combination of good technique and strong composition.

Formal elements – Composition

Photographers have only a certain set of choices to make an object visible in an image. They can choose or change the following elements: tonal value to create and alter form and volume; quality of light and the shadows; space; textures; colour; viewpoint and perspective; selection and composition (in the smaller sense of the arrangement of objects); camera controls (shutter speed/aperture); and lighting (studio lighting may be under the photographer's control). Like the answers to the question 'What makes a good photograph?' you can quickly see that these break down into the two areas of technique and composition. Photographic technique is covered on pages 22-27; what is left relates to the list of items known as the formal elements of composition.

In formal art education and the compositional analysis of paintings, seven formal elements are identified: line, shape, tone and form, texture, space and colour. Part of the creative photographer's task is recognising and dealing with these in a photograph.

Composition is the process of identifying the formal elements and organising them to produce a final image. It is the mental editing used by a photographer, which makes the final image easily 'read' by the viewer. Sometimes photographic composition includes the manipulation of light and the subject – more often, it is concentrated selection and emphasis.

'Composition is the process of identifying the formal elements and organising them to produce a final image.'

Line

To an artist, line can either be actual marks on the paper, a suggested boundary or even a virtual or 'optical' line inferred by other items in the image. Lines – their shapes and direction – can have a strong influence on mood in an image.

In photographs of people one of the strongest lines is the gaze line – we always look to see what they are looking at, whether the subject of their gaze is within the frame or outside can make a surprising difference to an image.

Photographic magazines and books talk about 'leading lines' – strong lines in the composition that 'lead' the eye to the subject. This is, however, not confirmed by modern research into eye movement. Our eyes and brain seek out areas of maximum information (small areas of high contrast and detail) rather than follow lines in the composition.

Shape

Shape is defined by one of the other formal elements, usually by boundary lines that may or may not actually be there. Shape can also be made of an area of light, texture, or colour. In the world of two-dimensional art, shading needs to be added to a simple shape in order to create the illusion of form by suggesting highlights and shadows. If the shape has mass, then form is said to have volume. The type of light and its position create the appearance of solidity in a photograph – control of light through understanding its effects on the subject is a vital photographic skill.

Tone and form

Light and dark are the fundamental photographic components. 'Black and white' was once the only kind of image available. However, a black-and-white image contains more than just black and white, light and dark. It has a full range of tones from paper white through light, mid- and dark greys to dense black.

In photography, it is the changes in light over the surfaces of a three-dimensional object that create the gradations of tone in the final image – the shades of grey or colour that the viewer interprets as form.

In digital photography, black-and-white images are referred to by a more precise description – greyscale. Photographers refer to the lightness or darkness of a grey or colour as 'tone' – you will often find artists refer to this same quality as 'value'.

Texture

Texture is the characterisation of the interaction of light and the surface; polished metal and glass surfaces are highly reflective and may even act as mirrors having no texture whatever. Wood has a texture from its pattern of tiny highlights and shadows, which is revealed as light falls across the grain. How to light in order to reveal or conceal texture is one of the most important techniques to develop as a photographer.

Space

Space can be either two or three dimensional. It more often refers to the depiction of the third dimension in a two-dimensional medium (the depiction of the third dimension in a two-dimensional medium is one of the most important aspects of photography and is something we will return to in this book).

Just as there can be positive shapes, there is also a strong sense of negative space or negative shape – these are the absence of volume and the areas left between positive shapes respectively.

Colour

Technically speaking, colour is the human perceptual response to different wavelengths of light energy that fall on the light-sensing cells in the retinas of our eyes.

Understanding the choice of colours in the photographic palette, restricting them to a range of colours, choosing colours that work in harmony or discord with each other, or choosing warm tone colours or those with a cool quality – these are all aspects of colour that must be dealt with by a photographer.

In addition, a photographer must also look at the technical aspects of colour, fidelity (faithfulness) in reproduction, controls management through the workflow, and the complex topic of lighting colour and white balance.

Colour has a powerful effect on our moods and emotions – it is a major tool in the creative photographer's kitbag.

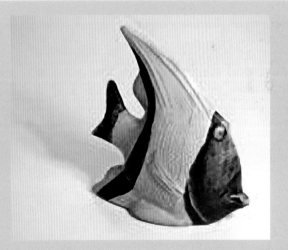

Principles of design

The formal elements of photography are qualities. They are characteristics of the subject – they are not processes. The principles of design are what you do with the elements – think of the formal elements as the ingredients and the principles of design as the cookery. The design principles are defined variously depending on the context; graphic designers, artists and photographers have different needs.
For photography, consider them to include: variety, pattern, contrast, symmetrical and asymmetrical balance and movement. Their use produces an image that displays unity, where each part of the image is necessary and all work together.

'Think of the formal elements as the ingredients and the principles of design as the cookery.'

Variety

Variety is easy to recognise, but it can be difficult to strike a good balance between the simply repetitive and the visually chaotic. It can mean using versions of the same or similar objects, or introducing a new and contrasting element: the same shape but a different texture, the same colour but a different shape.

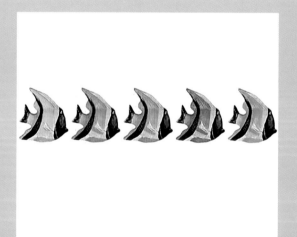

Pattern

Pattern needs as careful an application as variety to avoid unwarranted repetition. Some photographers, when learning their art, discover 'the pattern shot' and get sucked into seeing and photographing anything that repeats as though this was enough to produce striking and meaningful images.

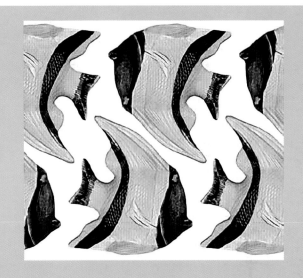

Contrast

For most photographers, the key design principle is contrast. This is not quite the same concept as contrast in the technical sense – the rate of change from black to white or dark to light – but it is the way in which formal elements are chosen to contrast, one with another.

Emphasis comes from the use of light or colour to attract and hold the viewer's attention. It is also a feature of lenses (which can be focused) and the application of depth of field. We will return to emphasis when we look at the technical aspects of composition.

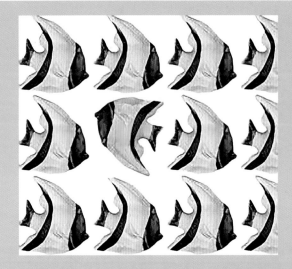

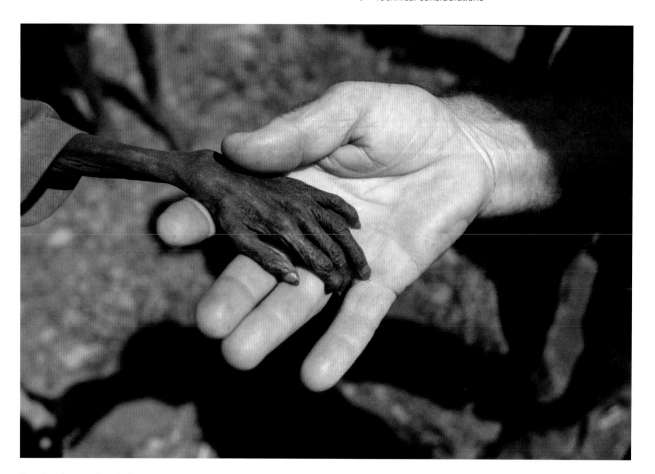

Starving boy and a missionary, Karamoja District, Uganda, April (1980) Mike Wells

The power of this prize-winning image comes from its many contrasts: colour, size, well-fed and malnourished, poverty and comparative wealth.

Balance

Visual balance can be hard to picture. With painting, the classical test was to divide the canvas down a central vertical line and judge balance between the two sides with respect to size of shapes, use of light and dark, etc. Balance does not have to be judged about a central line – a strong compositional element towards the frame edge may divide an image into unequal parts and shift the visual pivot point.

Balance can be from side to side or top to bottom, but there is also the important balance in the depth of an image between foreground and background elements. Symmetrical balance means features of equal visual mass are equally spaced around the pivot. Asymmetrical balance means a lighter or smaller object can be farther away from the visual pivot.

Movement

Movement is really the potential for an element to move. Nothing really moves in a conventional photograph, but picture a raindrop about to fall from a leaf set toward the top of a vertically framed image – every time you see the image you can imagine the drop falling.

◀ Principles of design
Technical considerations
▶ Exposure and reciprocity

Technical considerations

So far we have looked at the artistic - compositional - side of photography. The technical side can have as great an influence on the look of the final image. It is easy to think of the technical side of photography as being there just to get the thing in focus and well exposed, but as we will discuss later, photography has its own language separate from art. The technical side of the craft can be manipulated to creative and artistic ends.

Media

The choice of medium has to be where you start applying the creative photographic thought process. What imaging technique would best suit the job and carry your message? If you choose to capture your image digitally what degree of post-processing will you use? How manipulated and adjusted will the image be? You could choose to shoot on film, which still has a characteristic appearance distinct from digital imagery, black-and-white film in particular.

Focus

Let us look at some simple yet unique aspects of photographic technique. Lens-less photography – pinhole photography – has a following as it produces a unique look where everything is in focus from near to far. Lenses make photography unique – in particular their ability to focus and de-focus. This is one of the strongest techniques for holding and directing the viewers' attention.

Depth of field

Controlling the amount of light entering the camera lens with an aperture brings with it the effect known as depth of field – best described as zones of apparent sharpness both in front of and behind the actual point of focus. Photographers use depth of field to reveal and conceal parts of an image.

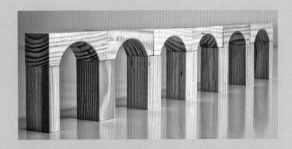

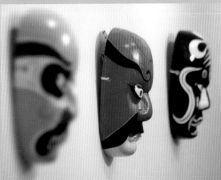

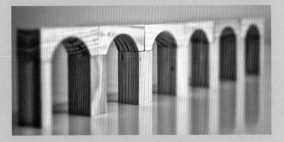

Depth of field

Choosing how much of the image appears to be in sharp focus is one of the major photographic techniques. The top image shows the whole viaduct in focus, whereas the bottom image focuses on just the third pillar.

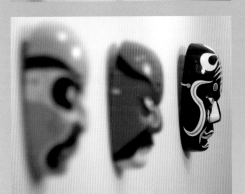

Selective focus

You can move the viewer's attention by carefully choosing where you focus in an image. In this sequence, focus moves from the grey mask, to the red, then to the black.

◄ Technical considerations
Exposure and reciprocity
► Language of photography

Exposure

While there is a technically correct exposure, there is also a subjective choice of exposure that can darken or lighten an image with under or overexposure. The depiction of tones and their distribution in the image produces what photographers describe as tonality. 'Key' is the word used to describe overall tone. The key (main) light in a portrait sets the character or the mood of an image – hence the use of this word. A high-key image is predominantly composed of light tones – low-key refers to an image composed largely of darker tones; these are not the same as under- and overexposed images as both still have a full – if dramatically skewed – tonal range.

Shutter speed

Aperture's partner in exposure is shutter speed, the choice of which gives the appearance of motion in an image: whether something is blurred or frozen in time (do not confuse blur from movement with something that is blurred by being out of focus).

Shutter speed

By choosing a fast shutter speed you can make the moving car appear to be standing still; a long shutter speed will produce motion blur.

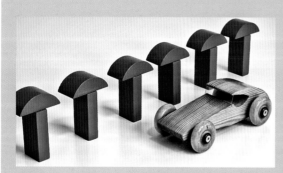
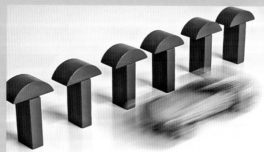

Exposure and reciprocity

The key to understanding how all light-sensitive materials work – whether film, a digital sensor or a child's sun print – is the law of reciprocity. At this point, many people give up on understanding how photography works because they feel the language has become impenetrably technical. The ideas seem too complex to deal with, but not so. If you know how to make a piece of toasted bread – and who doesn't? – then you already know everything there is to know about photography's feared law of reciprocity.

To make a picture using something that goes black in the light, you can see that there are two effects at work. If you've ever made a sun print, you'll already know that some days are better than others for getting good prints quickly. The brighter the sun and the less cloudy the day, the quicker the prints come out. On a dull day, it seems to take forever for the image to appear and you never get a strong 'contrasty' print. Photosensitive materials need a certain amount of energy to change. On a dull day when the sun is less bright, they take a longer time to produce an image. Time and brightness both have an influence.

Exposure

In terms of exposure, the same image can be made in a number of ways by combining intensity and duration.

Variables

The three variables of exposure: intensity, sensitivity and duration.

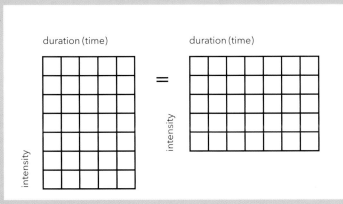

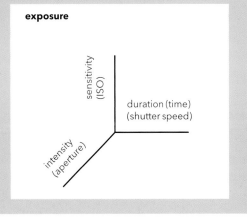

◀ Technical considerations
Exposure and reciprocity
▶ Language of photography

Toast vs photography

Photography 101 is simply learning how to make a piece of well-browned toast. What you need is a source of controllable heat. Say you use an electric grill, you can choose to turn the heat up high or leave the heat set low. To produce exactly the right degree of brown toast, you need to leave the bread longer under the low grill than when it is set to high. It takes longer to reach the perfect brown under a low heat.

Substitute light for heat and you have photography. Think of the film or digital sensor like the piece of toast. A good exposure is the right degree of browning. To get that, you can do one of two things. You can have the light up high and use a shorter time to 'cook' your image or you can have the light level down low when the perfect exposure takes longer to make.

The technical words used to describe this are intensity (brightness of light) and duration (how long the light falls). Their relationship is governed by the law of reciprocity, which simply states that the total light energy (exposure) is the product of light intensity and exposure time. This means you can make the same picture (in terms of exposure) in any number of different ways combining intensity and duration.

We have so far discussed reciprocity as the way the medium integrates duration (time) and intensity of light. This presumes an imaging medium of some standard sensitivity to light. There are in truth three variables in exposure, each having a reciprocal relationship: sensitivity (ISO sensitivity in digital cameras or film speed), shutter speed and aperture.

ISO sensitivity

Unless working with sheet film in larger format cameras where each exposure can be considered separately, photographers will tend to use and load a specific film. Without removing the half-finished film from the camera and substituting another, the whole film will be exposed at the same film speed. Most photographers using miniature 35mm film or medium-format roll film adopted this 'set and forget' attitude to film speed as a necessity. Because film speed has not needed to be considered at the point each exposure is made this has tended to prevent sensitivity from taking its proper place as one of the three equally important exposure variables.

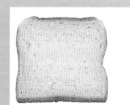 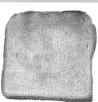 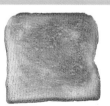 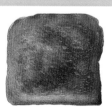

With the switch to digital cameras – early models showed poor noise performance at anything other than low sensitivities – there was little incentive to change from this way of working. As each new generation of digital camera has incrementally improved noise performance across a wider range of sensitivities, ISO sensitivity can finally come into its own as part of the exposure setting. When using a digital camera, sensitivity should now be routinely considered and, if appropriate, set on an image-by-image basis.

Automated settings

There is always a temptation to use automation to set exposure variables for you. The outcome can be mediocre and will undoubtedly need some adjustment to suit personal preference. As with autofocus, there is nothing inherently wrong with automatic exposure, but the photographer has to understand how and when to choose to override the suggested settings.

While amateurs choose so-called exposure scene modes, cameras used by professionals feature auto-exposure modes (P – Program) and semi-automatic modes that allow the user to choose one exposure variable (shutter speed, aperture) and have the other variables, including sensitivity, adjusted accordingly.

In the past, one had either shutter (S or Tv – Shutter or Time Value) or aperture priority (A or Av – Aperture or Aperture Value) modes. These are now being joined by sensitivity priority (Sv) exposure mode designed to automatically select the optimum combination of aperture and shutter speed for a user-selected sensitivity; and shutter and aperture priority (TAv) mode designed to automatically select the most appropriate sensitivity for a user-selected shutter speed and aperture combination.

By being in control of the relationship between intensity and duration (lens aperture and shutter speed), the photographer has control over depth of field and the appearance of motion. The aim is always to get a good exposure with detail in the highlights and shadows if appropriate, but one where there are no surprises.

Toast
Philip Lange

Reciprocity at work (left to right):
unexposed, underexposed,
correctly exposed, overexposed
and grossly overexposed toast.

◀ Exposure and reciprocity
Language of photography
▶ Putting it all together

Language of photography

Photography is an abstraction in the sense of 'abstract' meaning 'removed from'. While pioneer photographers and their viewing public took it for granted that the camera recorded some kind of scientific truth, this is most certainly not today's understanding of the medium. 'The camera never lies' was a phrase in common use. It reveals what store people put in the perceived 'truth' of photographic imagery. The modern philosophical view could well be summarised by saying that the camera not only never tells the truth but, more than that, it is actually incapable of doing anything other than lie – it abstracts and we interpret. What photography is abstracted from is in fact reality.

2D vs 3D

Even a photograph where the clear intention has been to make a true record of a real object is an abstraction. First, a photograph is selective. By its very nature an image frames some part of the world and by definition excludes the rest. Secondly, the photographic print is a flat two-dimensional representation of a three-dimensional world. It depicts a certain fixed perspective from a selected viewpoint. Humans have stereoscopic vision – our perception of depth and location is based on overlapping foreground and background shapes – these relationships are frozen in a photograph.

You cannot peer behind something in a photograph – the relationships are determined for you, the viewer, by the photographer. David Hockney referred to photography as a 'one-eyed man looking through a little 'ole'. How much reality can there be in that?

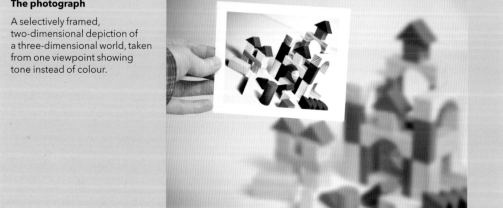

The photograph

A selectively framed, two-dimensional depiction of a three-dimensional world, taken from one viewpoint showing tone instead of colour.

Time and motion

The next degree of abstraction is that the static photograph has to deal with movement in a dynamic world. Time and motion become the realm of the camera shutter which can to some extent freeze time or integrate a period of time into a single image. A sequence of images can depict the passage of time, but is experienced in a quite different way from passing time itself – you can go back in a sequence and re-visit prior 'times'.

It pays to remember that the still image sequences of the photographer Eadweard Muybridge were instrumental in the development of the 'movies'. These remain nothing more than a projected sequence of stills done so fast that we perceive them as moving images.

Focus

There are other photographic attributes that come about because we use lenses as image-forming devices in our cameras. The first quality is that of focus. We are not usually aware of our own eyes moving in and out of focus, but a lens can either depict clear detail or hide detail depending on where it is focused in a scene. By controlling focus, a photographer can draw the attention of the viewer to certain aspects of their image and can conversely conceal parts of the scene in lens blur (see Focus and Depth of field on pages 22-23).

'Even a photograph where the clear intention has been to make a true record of a real object is an abstraction.'

◀ Exposure and reciprocity
Language of photography
▶ Putting it all together

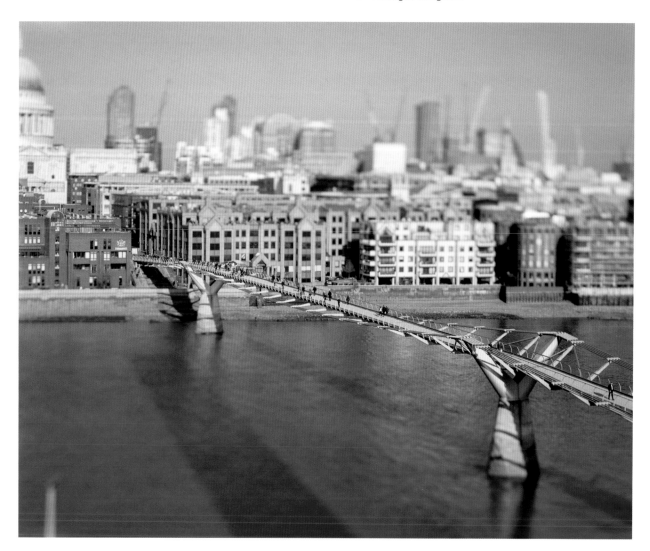

The Millennium Bridge across the River Thames in London
David Levene

A deliberately shallow depth of field, carefully chosen focal point and composition direct the viewer's gaze.

Aperture

We need some mechanism to control the amount of light entering the camera in order to produce a good exposure. Hence, we have the aperture – simply a variable-sized hole in the light path. This works like the pupil in our eyes, closing down to reduce light entering the system and opening up to let us see in the dark.

The aperture creates another optical effect unique to lens-based media – depth of field. This signifies how much of the image appears in sharp focus in front of and behind the point at which the lens is critically focused. For instance, is the background out of focus and blurred or does the photograph have clear, crisp detail running from the closest foreground objects through to the distant background?

The interplay between focus and depth of field gives the photographer a mechanism to direct the viewer's attention precisely where he or she wishes it to be. A complex set of visual games can be had where the subject can be clearly revealed and isolated from the background or conversely, the subject may be concealed in blur and the viewer intentionally distracted by the image-maker and given a visual puzzle to solve.

Photography as a language

So what is photography? The best way to understand photography is as a language with its own vocabulary and grammar. Its vocabulary is summarised in the box below. How these 'words' work together to give understandable and meaningful descriptions is the realm of composition. In order not to be just a jumble of words, language has to be about something. You can write a grammatically correct sentence that has no meaning: 'artichokes bypass caustic dogs'. Similarly, you can compose imagery that has no meaning. What puts meaning and message into a photograph is the photographer's intent.

The vocabulary of photography

Framing
realm of the medium

Three dimension to two dimension
realm of the medium

Dynamic to static (or moving to still)
shutters

Focus
lenses

Depth of field
lens aperture

Colour or black and white
realm of the medium

◀ Language of photography
Putting it all together
▶ Creativity and intent

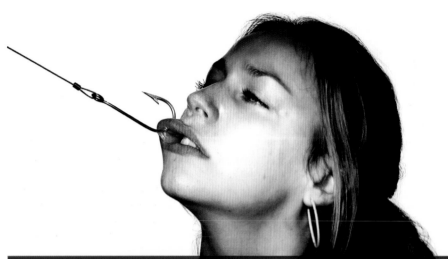

The average smoker needs over five thousand cigarettes a year.

Get unhooked. Call 0800 169 0 169 or visit getunhooked.co.uk

SMOKEFREE

**'Get Unhooked' - the NHS's
give up smoking campaign
Nick Georghiou**

A powerful message is
embedded in the single
visual concept in this arresting
image used in an anti-smoking
health campaign.

Simplify, simplify, simplify

This should be the
photographer's mantra. Most
amateur photographers worry
about what to put in their
pictures - the professional looks
for what they can take out in
order to strengthen the image
and refine the message.
Edit your pictures before you
take them.

Putting it all together

Composition is how we put it all together. Talking about composition when the subject is a written essay, people naturally mention what the essay is about. It is an odd observation that most people will talk about photographic composition and discuss the precise geometric placements of elements within the frame, but rarely talk about the content of the picture itself. It is rather like discussing a story, talking about the grammar and vocabulary, but never getting down to the characters and plot.

You have to look back where the photograph starts. It starts with the photographer's intent. A strong photograph starts with a selection of subject for a reason. Then comes the viewpoint and technical photographic considerations, followed by the 'linguistic' considerations of the image, which convey its meaning in a clear and precise language to the viewer. Composition is the process that puts all these together to create a coherent visual whole.

Use your eyes

Andreas Feininger's advice to photographers was to 'explore – isolate – organise'. By this he meant look before taking your picture – use your eyes before you use your camera. Move around; consider every viewpoint – near/far, high/low – before 'committing' your picture. Work out what is required compositionally, which elements need to be stressed, and which hidden or diminished. Use the principles of design to organise the image; include only what is required and then capture the image.

The sheer ease of digital photography tends to make photographers careless, shooting hundreds of potential images that will be culled later on the computer. It is far better to think beforehand and get it right at the time. Alternative angles and safety shots are fine, but saturation bombing of the subject rarely, if ever, produces a winning image.

Delivering the message

How do you know if an image has worked? Is your imagery fit for purpose? You can judge this based on the reaction of others to your images. Do they understand your message? Do they 'get it'?

Think of all the times a friend has shown you photographs with a running commentary explaining the significance of each image, what's included and what's not – one of those 'you-had-to-be-there' moments. Those are photographs where composition has not worked. Each image merely acts as an aid to jog the memory and provide a prompt to tell a story – a story that should have been told in the image. If you can honestly deliver a portfolio of images without needing to explain, you know you have succeeded in your composition.

Creativity and intent

Photography - often in the past supported by texts - has now found an independence of communication that puts it on a level with textual narrative.
If anything, it surpasses text in the speed with which it can deliver its message and in its inherent potential to globalise that message.

Image has to be about something - the message. It can be placed there intentionally (as with images designed to advertise or sell) or it can appear unintentionally from the photographer's subconscious (this type of imagery is more often found in the realm of fine art and personal expression, which is not the subject of this book).

Professional photographers are looking to produce images that have been constructed around a message, and to deliver them clearly and succinctly to the viewer. This is an intentional process that is instigated by the client's need to create a visual representation of their message. In some genres such as photojournalism - a professional, paid-for photographic form - the photographer's own message is the one conveyed, but is seen as appropriate for the chosen channel of publication by the publisher and editors.

Ideas and inspiration

Creativity is like an organism that needs to be nurtured in order to grow and flourish. It needs to be exercised and fed ideas and imagery – without these it will die. Strong, successful imagery draws from the process of constant cross-fertilisation with ideas based on new cultural references and alternative technical processes.

Photographers need to keep track of their ideas. Because they 'speak' a visual language, the chances are that their notebooks will contain sketches and image elements printed and torn from other sources (although more often than not, the 'notebooks' are virtual and take the form of a laptop computer or a compact camera). Photographers, however, cannot develop fluency in the language of photography simply by surfing the web. They need to see real images to understand the power and quality of work produced by the leaders in the field.

Developing your eye

Develop your photographer's eye by looking at other people's pictures questioningly. Ask yourself both about the clarity of the meaning and about the quality of the techniques. Look at plenty of photographs and look often. Photography is an expressive medium. If you do not express yourself through the medium, you cannot convincingly create imagery that expresses others' ideas.

In addition to taking in information from as many sources as possible, you should be producing visual work. In the beginning, this may be in as many styles as possible to help you master the technical aspects of photography, and also to become fluent in its language. What marks out the successful in their field is their ability to use the language of photography intentionally and not accidentally.

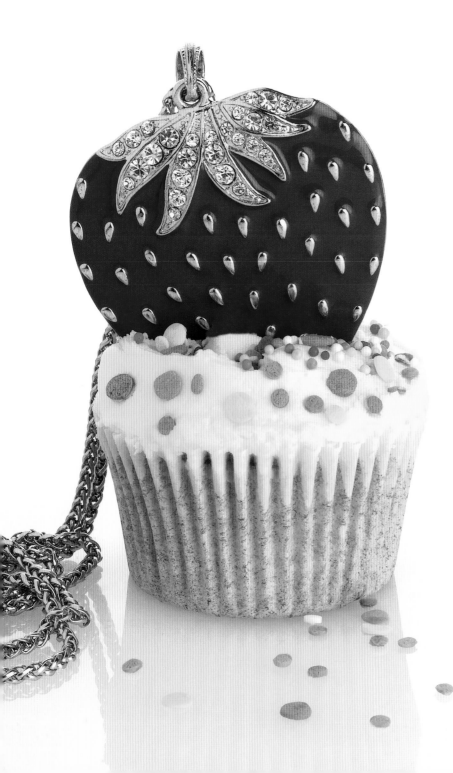

**Strawberry necklace
and cupcake
Caroline Leeming
(styled by Amy Bannerman)**

This image presents a single
strong concept used
to create a humorous and
attention-grabbing commercial
still-life image.

1

Photographic fundamentals

Communication

Communication (n.) the conveying, exchanging or sharing of information with mutual understanding

Applied photography

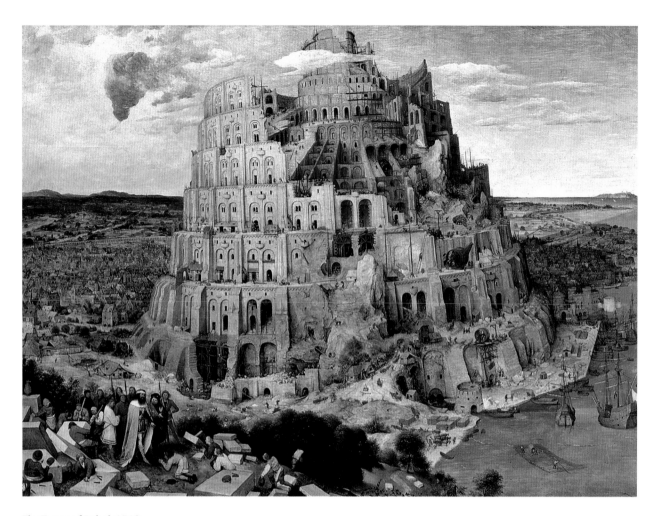

The Tower of Babel, 1563
Brueghel Pieter the Elder

Sometimes called 'Tower of Babel and the Confusion of Tongues', this story reminds us that we must share a common language in order to communicate. Some would consider photography as one of these common languages.

In order to communicate successfully, we have to understand and share the same language as those with whom we wish to communicate. For the photographer, this means that not only do you have to create images, but you must also be able to 'read' them. Cultural references may need to be précised and packaged for people who may not be familiar with them. For example, if you wish to create a 'grunge look' for a particular image, imagine the difficulties in describing that to a client or a model who has no idea about the original 1990s style, let alone understand that you might wish to use it retrospectively or even ironically.

In the field of creative applied photography, the photographer is a middleman between the client and the viewer. The photographer must understand and interpret the client's instructions, but must also be able to explain to the client how this could be achieved photographically. In a commercial setting, the photographer must then convey this to the viewer in an image that communicates clearly any message that has been agreed.

In some areas of creative applied photography – (photojournalism, for instance) – the photographer will be working much more independently, but will still need to be able to work and communicate with an editorial team. They must also be able to discuss much the same aspects of their imagery as a photographer working in fashion or advertising.

If a photographer is working to a specific brief, they will spend a lot of time talking about imagery and verbalising the visual during the early stage of the process. Once client and photographer have agreed a visual approach to be adopted, the photographer then has to turn their attention to the end-user – the viewer. What was discussed with the client now has to be converted into a visual message for the viewer within the creative bounds and the budget agreed. The discussion that needs to take place in order for this to happen must cover a lot of ground. There will be three particular areas to cover: the technical aspects of the image; the artistic approach; and the overall mood or emotional content of the imagery.

In developing a project brief, these will commonly be taken in the order: mood/emotion, the artistic 'look' and the technical way in which that look will be achieved. The client may not need to know how the look will be achieved, and the technical aspects of the shoot left solely to the photographer, but there will be times when it is necessary for the photographer to describe certain technical aspects. This may be to support decisions over budgets where specialist photographic lighting or equipment needs to be hired in order to achieve a particular effect, or for travel to specific locations.

Visual literacy

Communication is the two-way street of sending and receiving messages. Visual communication relies on images for this communication. Images work faster than the written word in delivering their message; they also work globally. It is now clear that the culture of the written word is moving inexorably toward communication by image - this visual literacy is replacing textual literacy.

Visual literacy is fluency in the language of the image. This is similar to fluency in any spoken language - you have to use the language regularly to become competent and confident in its use. There is also social fluency. This means the language is used in different ways in different parts of society. The language a photographer uses in the studio with other photographers, assisting photographers, models and designers will not be the same language used in a formal presentation of ideas to a client, even though the same image is being discussed.

**'A dream of flowers', 1985
Duane Michals**

Duane Michals does the big issues of gender and mortality - sex and death - as in this sequence from the book by Marco Livingstone entitled *The Essential Duane Michals*.

The sequence is called 'A Dream of Flowers' - it would be a literal interpretation of the title were it not for the four images being progressively labelled A. I. D. S.

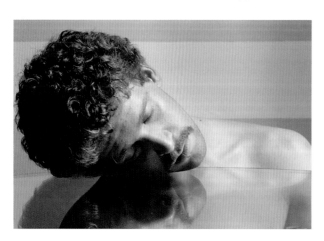

A.

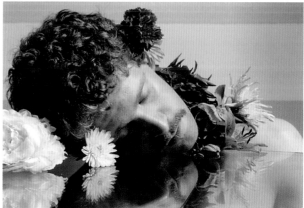

I.

Interpreting images

Literacy means being able to both interpret other people's images and produce your own meaningful and communicative images. It involves the skills taught today as 'critical studies', which include collecting, analysing, reflecting on and critiquing images, as well as composing images and manipulating their content. There is also an important judgemental element in visual literacy – you must be able to reach considered decisions about imagery regarding issues such as its authenticity, validity and worth. Lynna and Floyd Ausburn pointed out the importance of students being taught to 'distinguish superficial, glamorous and pseudo-sophisticated messages from real and valuable ones'.

Narrative

Images can be used to tell stories – this is described as narrative. Sequences of images can tell stories that involve the passage of time and allow us to compare and reflect on various points in the progress of the story. A sequence may be linear; it may be branching, never-ending and circular, or even without a real beginning or end.

Master of this form of photographic communication is Duane Michals. His image sequence 'Things Are Queer' takes you from a bathroom of ambiguous size through a mirror and a picture-book image of that bathroom, down a corridor and back into the bathroom again, normal sized. Michals's biographer, Marco Livingstone, says the sequence is 'like being taken on a tour of the universe only to be dropped off at the original point of departure, none the wiser'.

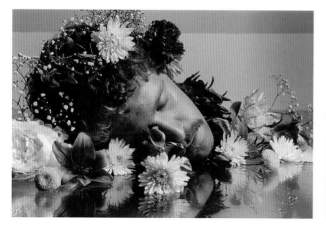

D.

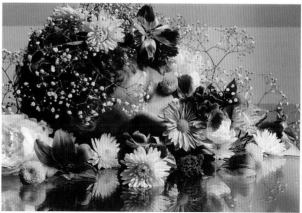

S.

Ownership

It may seem odd to introduce the complex idea of who 'owns' a photograph so early in the book. It is, however, important to understand that the image created as part of creative applied photography is not just the photographer's alone. There are both philosophical and legal dimensions to the idea of ownership. An image may contain a great deal of individual creativity, but it is not there simply as a form of self-expression; it is there as a conduit or channel for a message. Who 'owns' the image and who 'writes' and controls its message is important to an understanding of how the creative imaging industries work.

The four owners of an image

The photographer
the producer or taker of the image

The subject
the person seen in the photograph

The editor
the individual(s) or organisation(s) who makes the images available to the public

The viewer
the audience

The needs and rights of each of the above will differ from image to image, and may be expressed even before an image is taken.

The photographer

Obviously, as the photographer, I own the image. Actually, no. If you produce an image of yourself and keep it to yourself then perhaps you are the only owner of that image. There are those who would argue that a photograph does not really exist at all if it is not seen and shared. Sharing an image means showing it to other people – they have a reason for looking and sometimes a vested interest in the content of the image. They exert their own influence over its content – sometimes even before the image is created. They can therefore be considered 'owners' of what the image contains.

The subject

Some think that if the subject of the photograph is a person, clearly, they in some sense also 'own' the image. This particular debate has become very heated in recent years as it concerns issues of privacy. Moral rights begin to change into legal rights when the subjects of photographs wish to take and exercise ownership rights over the distribution and publication of the image.

Importantly, privacy laws and 'rights' over the ownership of photographs of others differ on a country-to-country basis. Some countries enshrine the right to privacy in law, others do not. The legal implications of taking pictures of other people, how you respect and perhaps even buy out their ownership rights, are covered in another section of the book (see pages 152–155).

The editor and the viewer

Publication of an image is literally that – to make it public and to show the image around, which may be a formal or an informal process. There is some evident blurring of those boundaries in the use of photographs on social networking websites such as Facebook or MySpace. Some people have posted images that have been used by commercial organisations without permission – sometimes in blatant disregard for the owner's rights.

The originator's ownership has been ignored and in effect ownership and control of the image taken from them. There are individuals and organisations that have a formal role in making images public – these are the publishers and editors who work for news agencies, magazines, books and websites. They, too, have ownership of the image in one important sense that without their say-so the image will never reach the viewer – the readers and subscribers. They choose the images that reach you.

The four owners of an image

This diagram illustrates the relationships among the four owners of an image: the photographer, the subject, the viewer and the editor/publisher.

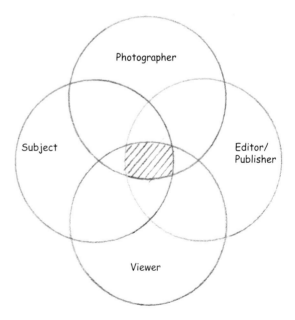

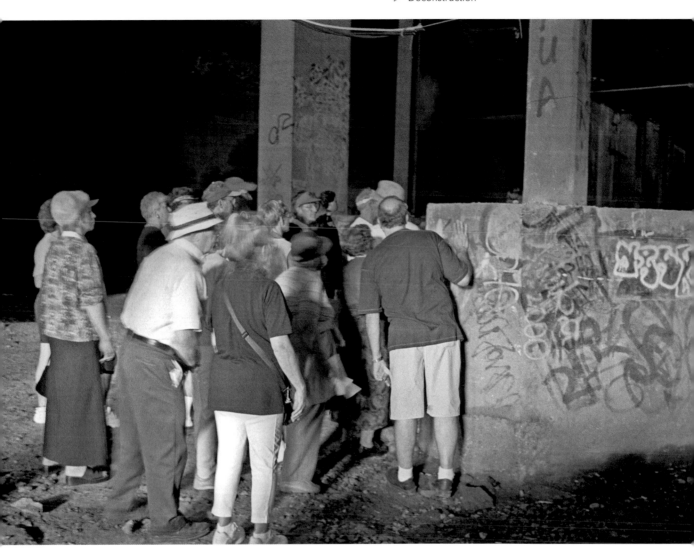

Reading an image

To be able to talk about images we need to be able to read them. A photographic print by itself tells us nothing - it is purely a record of the fall of light during the specific period of time the camera shutter was open, presented in two-dimensional form. The image might be in colour or further abstracted in the grey tones of a black-and-white photograph. It may even be the reproduction of an original photographic image in a book.

Everything else comes from our recognition of patterns or areas of tone as objects, and the use of our mental powers to build some meaning - voluntarily or otherwise. Humans are good at solving puzzles and will naturally try to work out what they are seeing in every image they encounter. Everything else that you bring to an image comes from your memory and emotions and these are projected on to the image.

What is this image about?

You will not have seen this image before - it has not been published though it has been exhibited once and is used for teaching. It is fairly certain you have not seen it before. Try to read this image.

Responding to images

Once you have read an image, you may be expected to make some response to it. The two least useful responses you can make to an image are: 'I like this picture' and 'I think this a good/bad picture'. The first is a completely personal comment and if anyone wishes to enter a dialogue about your views it immediately takes on the appearance of a personal attack. It certainly limits discussion. 'I like this picture because…' is a much better start. The second statement – that a picture is in some way good or bad – is again a closed comment. The criteria need to be explicit. Good or bad for what?

The picture on this spread is about fear of the unknown and our tendency to cohere as a group when stressed or threatened. It is a psychological portrait – a picture about a state of mind. Showing this image in class produces a wide range of explanations, many based on imagination or personal experience. Reactions have ranged from complete indifference to real fear.

The image was taken during one of the rare public openings of the old Rochester subway station accessed by foot along the Broad Street aqueduct. The small party peers into the dark, trying to make out what they can of the long-abandoned station. The huddled, almost fearful, stance of this group of people is clear. They move close together for safety – but from what?

Why is this image a portrait and not a still life?

Before turning the page, start working out what this image is all about – catalogue the contents. Ask yourself why it could be argued that this image is actually a portrait.

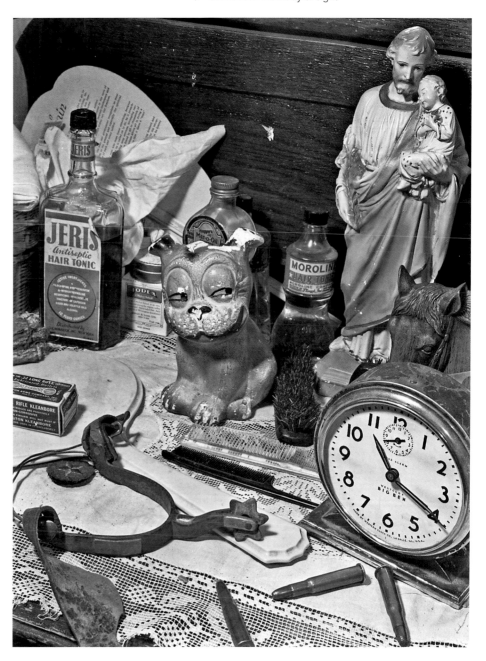

Deconstruction

Deconstruction is a process of critical analysis originally popularised by the French philosopher Jacques Derrida in the late 1960s. First applied to philosophical and literary texts, it has been adopted by commentators on art and photography as these works can also be treated as 'texts' capable of analysis. If you want to know how something works, you must take it apart. You then look at the components, how they interact and put it back together.

Deconstruction is simply that process applied to art. It is the analysis of visual communication. So, how and where do you start to dismantle a photograph? The simplest thing to do is to look at the image and list everything that appears in it. Catalogue the contents and work out what they mean. You may already begin to answer the question: what is it about?

Contextualisation

The next stage is to put the image into context. There are many aspects to this process known as contextualisation. Technical photographic information is just one aspect. The chosen technical approach may have some bearing on how the image is intended to be read. Contemporary photographers using long-abandoned photographic processes could inform you that the image is to be seen in a fine-art and not a documentary context. Arnold Gassan, a photographic educator, states that: 'Often, neither the viewer nor the photographer realises what is communicated by the photograph and what is brought to it by the individual viewer.'

The original social and historical setting is important. You must ask: who is or who was the intended audience? The story of the image as an artefact may even be relevant. The physical context of the image, including any captions of text, will all have a bearing. Any subsequent judgements you make about the image require criteria.

Cataloguing the content

The photograph on this spread was taken by Esther Bubley. It is a perfect choice to show how deconstruction proceeds and was first presented by Arnold Gassan, a photography professor from Ohio University. At first sight, the image appears to be a still-life photograph. Start working out what this image is all about and catalogue the contents. Ask yourself why I would argue that this image is actually a portrait.

◀ Reading an image
Deconstruction
▶ Semiotics – the study of signs

Analysis

Esther Bubley's photograph on the previous spread is entitled: 'Top of Stuart Haby's Dresser, Texas, 1945'. It is part of a documentary project for the Standard Oil Company, New Jersey (1943–1950). It is also part of a photo-essay looking at the life of an oil town in Texas by a female photojournalist, well known for her interest in people. The commissioning agency was run by Roy Stryker, who had formerly been associated with the Farm Security Administration.

Though Bubley's image could be described as being little more than a collection of objects, this image gives us a strong impression of the objects' owner: a hardworking rancher, concerned over his appearance, possessing a sense of humour and a sense of religion. The significant details of this image rapidly build a clear picture of the rancher, evoking his personality by juxtaposing the religious and the comic, the mundane and the extraordinary. The photographer has chosen to frame just these items in their original context, and has chosen the lighting and viewpoint.

What becomes clear from this process of deconstruction is that some time and effort is required on the part of the viewer to analyse and divine the meaning of this image. Although no person appears in the photograph, it gives a clearer portrait than any that would have been obtained by sitting the rancher down and photographing him straight-on or in profile.

However, if the viewer does not look carefully there can be no communication. These objects are what they are – there is no hidden significance here. But where the photographer alludes to things and uses layers of meaning or a system of signs in their picture, the task becomes more difficult and requires more effort from the viewer. It is clear from this image that photography can tell us as much about what is not in the image as about what is.

Do not disregard the initial and obvious meaning of an image. Hidden meaning may come out under careful examination and these will be influenced by your own knowledge and experience. This is a process you need to be aware of when looking at images and ask: how much of my analysis was involuntary and projective? In other words, did you unconsciously transfer your emotions to someone or something in the image?

The discovery that this image includes items of ammunition can have a strong influence on some people's perception. This explains why one image can mean quite different things to different viewers, and that meaning can be attributed to an image that was not intentionally placed there by the photographer. What may start as an intellectual rebuilding of meaning from an image may become changed by the projection of emotions, consciously or not, on to the image. Composition and framing can also affect judgement.

'Hidden meaning may come out under careful examination and these will be influenced by your own knowledge and experience.'

Catalogue of the picture

Handkerchief

Paper fan

Three bottles of hair tonic

Box of Iodex antiseptic ointment

Box of .22 long rifle
small bore cartridges

Two combs and a hair brush

A worn spur

Three high-velocity rifle bullets

A battered plaster comic dog figurine

Religious statuette of Joseph
and baby Jesus

Alarm clock

Statuette of a horse

A hand mirror

Lace-edged runner covering the top
of a chest of drawers or dresser.

Would the effect be the same if these
objects had been photographed
individually out of their context?
For example, would it have the same
impact if the objects in the image were
presented in a line?

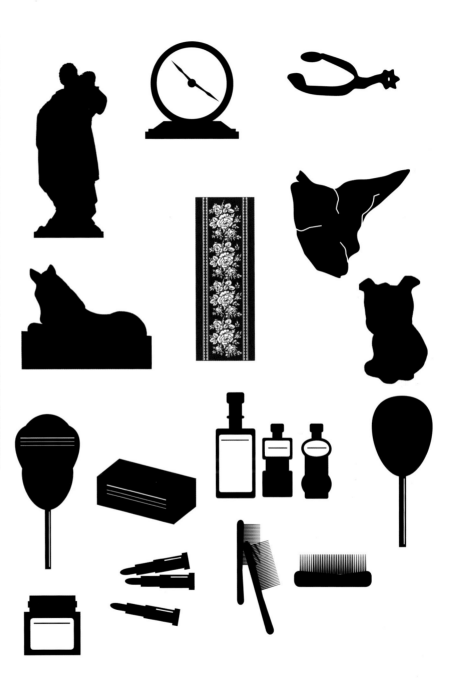

Sign = Signifier + Signified

The sign warns you of pedestrians in the road ahead – the red triangle in this system is the signifier 'warning'. The signified concept is represented by the outline figure of pedestrians. The sign does not warn you of a black cardboard cut-out of an adult and child ahead, but of the generalised concept of a possible hazard of pedestrians – maybe one, maybe five, maybe young or old – in the roadway up ahead.

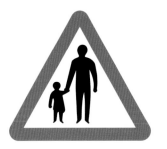 = +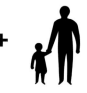

Another sign

You may not be familiar with this particular system of road signs but you can work out that the yellow diamond is the signifier and the strolling man the signified. Another sign for 'Warning – pedestrians on the road!'.

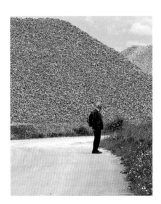

Semiotics – the study of signs

Study any language and you'll soon discover semantics. This is the part of linguistics that concerns meaning. Visual language has its syntax (formal elements) and its grammar (composition). It also has a department of semantics, which is related to and more often met in the context of visual imagery as semiotics or semiology – the study of signs. Everything in an image can be treated as a sign. A sign is simply a thing – whether that is a real-world object, a word, something in an image or even an icon – that has a particular meaning to a group of people. The sign is not the object by itself, nor is it just the meaning, but the two together.

Signifier

An image that represents a concept is called the signifier. That concept, whatever it is, is called 'the signified'. The sign always comprises the signifier, the object and the signified. They are only distinguished for the purposes of analysis, as in practice a sign is always the object plus the meaning. Signs always address somebody. There are systems of signs – road traffic signs and computer icons are two examples. These are described as referent systems because any sign taken from that collection, whether it is found in an image or placed in an ad, refers back to the system. Having or putting signs in an image is known as signification.

All these examples and more

Advertisements

Roland Barthes, philosopher and linguist, stated that: 'In advertising the signification of the image is undoubtedly intentional'. Whether you intend to work in the advertising industry or not, advertisements are probably the best place to study meaning in photography. It is easier to understand visual language in advertisements because everything in the ad has been put there for a purpose – nothing in that image has been left to chance.

Irving Penn's image 'Food of Italy' was commissioned as an editorial, not an advertising image. It uses food items in the colours of the Italian flag to evoke an association with the Mediterranean lifestyle. Unfortunately, we are not permitted to reproduce Penn's image here (see *Still Life: Irving Penn Photographs, 1938-2000* Thames & Hudson 2001, ISBN 9780500542484). The signified concept is all that is associated with Italy – it is a conceptual still life as it is not just an arrangement of inanimate objects for the reasons of aestheticism.

You can see the same ideas at work in the PERONI NASTRO AZZURRO beer advertisements where carefully constructed imagery is based solely on the colours of the Italian flag (red, white and green). Differentiation is making one product different in some regard from another. This may be a bottled beer, but it is different from all other bottled beers because, according to the brewer, it is 'Italian style in a bottle'.

The PERONI NASTRO AZZURRO refrigerator advertisement not only calls up the associations of the Italian spirit with these colours. It adds a red dress (hot and sexy) in a cool fridge. And what could be 'cooler' (kick off your shoes) than using a 'fridge' as a wardrobe? These signs are taken from the referent systems, placed in the advertisement and refer back to that system – all of which is associated with the beer we now 'know' to be full of Italian verve.

In the second PERONI NASTRO AZZURRO ad the same colour associations are used, but a woman is featured with the colours of Italy running languidly down her face. Note the colours appear in the same order as in the tricolour Italian flag. There is the suggestive placement of the bottle near the woman's lips and the dynamic effect of the paint runs that are not parallel to the page – they create a tension because they are not doing, in the viewer's world, quite what they should.

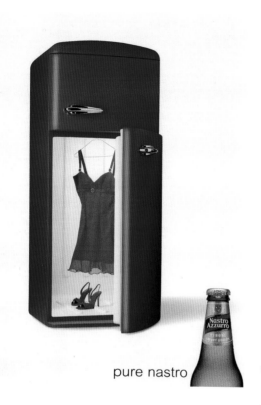

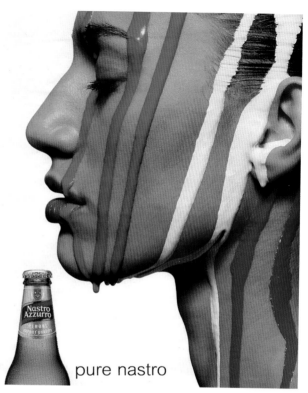

pure nastro

pure nastro

**PERONI NASTRO
AZZURRO** advertisements
**PERONI NASTRO
AZZURRO**

The PERONI NASTRO
AZZURRO advertisements
make use of the Italian flag's
colours in their campaigns
in order to easily connect
with, and create meaning
for, the viewer.

Influences

There are big influences at work on how we 'read' an image. The social and historical climate when the image was made is important to understand, especially if these aspects have changed – society's attitudes to nudity, for example. As mentioned earlier, personal experience and understanding will affect how you interpret an image. To cite an extreme, your attitude to an image of poverty or abuse would be heightened and directed if you had experienced those circumstances yourself.

'Personal experience and understanding will affect how you interpret an image.'

Perceptions

Responses to an image can differ wildly and perceptions be dramatically altered by historical fact. Take for example, the image on this spread. On one level, it is simply a picture of a young girl asleep in her daybed. That it was taken by someone other than a family member may change your perception – the fact that it was taken by a Church of England clergyman may also change your opinion of its meaning and purpose. It is not an isolated image, but one of many taken by this individual of the child (and of her two sisters) – 'Xie' was her pet name.

Over half the surviving images by this important photographer are of young girls. He later destroyed a large part of his photographic work, including nude studies of children. The photographer, the Reverend Charles Dodgson, was perhaps better known as Lewis Carroll, author of *Alice's Adventures in Wonderland* and the sequel *Through the Looking-glass and What Alice Found There*.

Today, internet commentators condemn Dodgson as the 'patron saint of paedophiles' and appear to be completely – if not pointedly – unaware of Victorian society's deep fascination with childhood. Both nineteenth-century art and society elevated the young girl as an ideal of purity and innocence. Some artists of Pre-Raphaelite Brotherhood considered that the only thing of beauty to everyone was the face of a female child.

You may notice how the author has steered your thoughts by the specific order in which the 'facts' pertaining to this image, the subject and photographer have been presented.

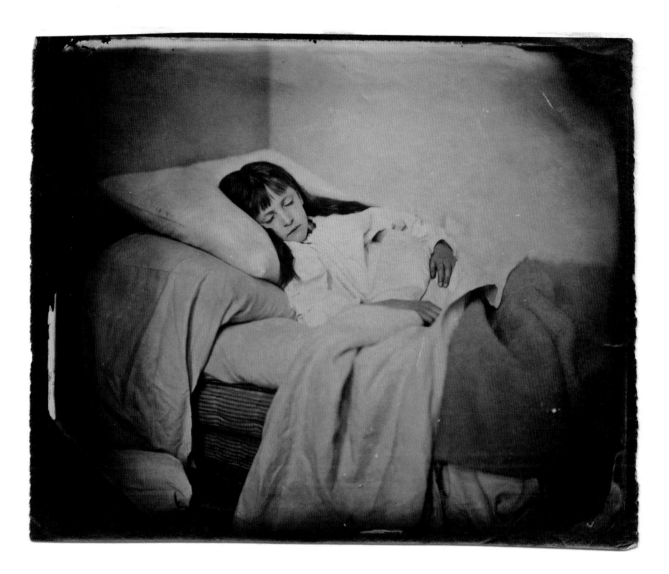

**Rosy Dreams and
Slumbers Light (1873)
Charles Dodgson**

Alexandra 'Xie' – daughter
of the Reverend George
William Kitchin – was one
of Dodgson's 'child friends'
and a favourite subject of his
throughout her childhood.

◀ Influences
Talking about photography - technical language
▶ Talking about photography – artistic language

Talking about photography – technical language

It is important to be able to precisely describe the effects of various photographic techniques and the application of different equipment in clear technical language. This is especially important when you need to talk to other professionals about how to achieve a particular technical effect. Technical language used loosely can quickly lead to misunderstanding between clients and designers about how the finished image will look or what equipment is needed to produce a particular effect. Be precise.

Kinetic (Seiko)
Tim Wallace

Blur – can be produced by movement. Motion blur results in the motion of the camera or the subject, while lens blur is produced by an out-of-focus lens. They look quite different. Filter and diffusion effects are also described as blurring or blurry as they make an image unclear and less distinct.

Colour cast – an unwanted, overall colour change in an image.

Contrast/gamma – perceived difference between the light and dark areas in an image – the rate of change from light to dark. High-contrast images contain mostly light tones and dark tones, shifting rapidly from light to dark. Low-contrast images contain mostly midtones, while normal contrast images show a regular distribution of tones from highlights through mid-tones to shadows.

Depth of field – apparent sharpness in front of and behind the exact point of focus. Depth of field changes with lens aperture, format and focusing distance. It is one way by which the photographer directs the viewer's attention.

Exposure – total amount of light allowed to fall on film or the sensor in the camera; the act of taking a photograph. Exposure Value is a single number that represents a range of equivalent combinations of aperture and shutter speed.

Focus – clear definition in an image. It is the principal way in which a viewer's attention is held. An image that has been intentionally de-focused can be said to be out-of-focus or blurred.

Format/aspect ratio – there are three main formats in film photography: medium format (MF), large format (LF) and miniature format (35mm and smaller). Different aspect ratios – image width divided by height – can be imaged on the different film formats. Most digital cameras are based on the traditional 35mm film aspect ratio of 3:2, some 4:3.

HDR (High Dynamic Range imagery) – a technique used to overcome limited dynamic range of camera systems to create images that more closely match human perception of shadows and highlights. HDR files are tone mapped to produce an image for display or printing.

Lenses – lenses are commonly described by their angle of view, which relates to their focal length. Prime lenses have a single fixed focal length while zoom lenses offer a variable range of focal lengths in one lens – not to be confused with telephoto lenses that make distant scenes appear closer.

Negative/positive – process that revolutionised image-making in allowing multiple prints from a single negative. The camera negative has the real-world tones reversed with black as white and white as black. These are again reversed to create a normally toned image in the positive print.

Perspective and viewpoint – how we interpret three-dimensional space in a two-dimensional image. Viewpoint is the one point in three-dimensional space where the camera is placed which determines that perspective.

Plane of focus – imaginary flat plane that cuts through the subject where the lens is focused.

Sharpness – subjective term combining the ideas of resolution and acutance. Resolution is how much detail or information there is in an image while acutance is how cleanly edges are handled. A sharp image is clean, crisp and detailed.

Speed – film speed describes how quickly the photosensitive materials react in light to turn black. The standard set for film is mirrored in the ISO sensitivity settings for digital cameras. Bigger numbers mean greater sensitivity to light.

Stops – a halving or doubling of light that can relate to aperture, shutter speed, luminance (light from a studio lamp) or even sensitivity. 'Stop' is the language of photography.

Tonality – tonal quality, relating to the range of tones used in an image.

View camera – simple large format cameras with a lens on a board attached by a set of bellows to a ground-glass screen, which shows the image reversed and upside down. To take the picture a film holder (dark slide) is inserted.

Warm/cool – changes in colour temperature away from neutral daylight white. Shifts towards yellow/amber (confusingly reducing the colour temperature) are described as warm because of the psychological associations; shifts towards blue (actually increasing the colour temperature) are described as cool.

◀ Talking about photography – technical language
Talking about photography – artistic language
▶ Talking about photography – emotional language

Talking about photography – artistic language

The language of the art world is often as impenetrable and specialised as photographic jargon. Here are some key words, concepts and phrases that you might encounter when discussing the approach your imagery is to take with an art director or other members of a creative team. There is even greater room for misunderstanding here if terms are not correctly applied.

Atomic Tea Party
Jo Whaley

Aesthetics/taste – concerned with the appreciation of beauty; the ability to recognise and distinguish aesthetic standards.

Authenticity – emotionally appropriate and significant.

Collage/montage/'joiners' – photographic composition made from pieces of new and found photographs, other media and sometimes printed materials. Montage means to select, edit or cut together – to make a composition from fragments. Artist David Hockney explored perspective, time and space using large canvases made of individual Polaroid or mini-lab colour prints joined together.

Concept – an idea that has been developed.

Connote – something suggested or implied. Denote refers to the primary meaning of something.

Constructed image – effectively an art installation, the final purpose of which is to be photographed. An image that has been built and is therefore not 'found'. Staged photography is related – where situations are acted out and photographed.

Context – the setting for an image, which might include texts, or a publication, an exhibition as well as social and historical aspects.

Explicit/implicit – something that is clearly stated (explicit) as opposed to something that is implied or inferred (needs working out).

Genre – categories of composition or methods of artistic approach. Sometimes used dismissively.

Iconic – some person or object, immediately recognisable, that stands as representing a particular era, place or group of people (seriously overused word often mistakenly for 'celebrated').

Juxtaposition – putting together two ideas or concepts for contrast – juxtaposition may suggest an unexpected third effect.

Modernism – a break with classical or traditional forms. In photography, this means a move away from the painterly effects of pictorialism, allowing the photographic medium to speak for itself in realism or straight photography.

Narrative/sequencing – to tell a story in a single image or in a related group of images, often without the need for supporting texts.

Negative space – the space in the photographic frame not occupied by the subject; the space around or between the subject(s).

Pictorial – like a painting or picture illustration. Pictorialism was a photographic movement that stressed the beauty of the image and subscribed the notion that photography should look like paintings or drawn illustrations; swept aside by modernism.

Postmodernism – literally 'after modernism' – a fluid style and concept that grew from critical theory and a dissatisfaction with art theories to invigorate all areas of the visual and literary arts in the latter part of the 20th century. Typified by appropriation of earlier styles, of a sense of the absurd, a rejection of elitism and an incorporation of elements of commercial art and mass production.

Praxis – the application of what is learned – artist's practice.

Snapshot aesthetic – constructed or deliberately staged photograph to look like a casual and informal image, quickly taken to eschew any sense of photographic technique or aesthetic.

Symbolism – the use of signs and symbols in an image to represent ideas or certain qualities.

Talking about photography - emotional language

Talking about what an image will make the viewer feel is possibly the most difficult area of photographic communication. In creating imagery for commercial use, the impact it makes on the viewer's emotions will be uppermost in the minds of advertising clients and their creative personnel.

**Beth, Paul, Gavin and Emma,
taken from *Armed America*
Kyle Cassidy**

Ambiguity – imagery that may have more than one meaning or where the meaning is unclear or uncertain. Can be used as a device to imply or hide a secondary message.

Candid – in photography this means taken without the subject's knowledge, but can also mean frank or completely honest.

Challenging – imagery with strong content that is difficult to ignore and which may be taboo. Sometimes used as a euphemism for images lying on the very boundaries of taste, for example in the context of sex or violence – one step beyond 'graphic'.

Concerned photography – politically or socially motivated photography that seeks to expose and correct social 'ills'. Photographers adopt a head-on realism that is sometimes appropriated as a fashion style.

Confrontational – imagery that faces up to a situation and deals with it in a direct and compelling way.

Detached/dissociated – to keep one's distance or to split off from an emotion. Irving Penn's work has been described as having 'cool distance', for instance.

Empathy – the ability to share another person's feeling – to empathise is to share their emotion and understand their point of view.

Enigmatic – imagery that is mysterious and which poses a riddle – open to many interpretations, not all obvious.

Evoke/evocative – literally, to bring to the conscious mind; the sense of an image calling up emotions, feelings or memories.

Intimate – imagery that seems private and personal but which speaks directly to you, the viewer, to the exclusion of others – often sexual or erotic in nature.

Mood – the atmosphere or pervading tone of an image be that sad, happy, or which evokes more complex emotions and situational memories.

Nostalgia/nostalgic – to hark back to a past that is perceived as better than the present – painful, sentimental longing.

Spiritual – related to things other than the physical world; unconcerned with material values. Can be sacred and divine or unconnected with religion.

Stark – severe in outline or form; can have an element of unpleasantness or being unavoidably stripped of something.

Unsettling – imagery that makes the viewer anxious or simply ill at ease: otherworldly, macabre, haunting.

Vibrant – full of energy (as if resonating or vibrating), often used of strong contrasting colours or patterns.

Visceral – means literally 'of the gut' – bringing out strong, powerful and deeply moving feelings.

Warm/warmth – generates good feelings or emotions.

2

Communication

3

Applied photography

Applied (adj.) (of a subject or study) able to be put to practical use, as opposed to theoretical

Photography (n.) the art and practice of recording images on light-sensitive materials

4

Professionalism

Portraits?
Various sources (see page 66)

Without their individual
contexts these images seem
to be just six simple portraits
of men – turn to the next spread
to find out more.

Your first encounter with photography was probably with family snapshots. These images are taken to invoke memory or to record events, people and places for personal reasons. The technical quality of the pictures is often completely unimportant. Hobby photographers, on the other hand, explore the conventional aesthetics of photography through camera club competitions and their personal work. For some, photography becomes a valid form of self-expression and exploration.

This book is concerned with an entirely different side of photography where a photographer is hired by others to create imagery. The hiring and reward aspects - which mark the work out as being professional - will be covered in subsequent chapters. The important aspect of the creative imaging industry is that the vast bulk of the imagery is created for a specific purpose, usually the promotion or sales of products or ideas. There are, of course, professional photographers working in the news media, so how can we define the type or types of photography to make sense of what kind of images get created for reward?

At its simplest, you can break photography down into three big areas based on the subject: the photography of things, the photography of people and the photography of events. The photography of things is concerned with the documentation and possibly selling of objects - this could include cosmetics, cars, clothes or computers.

The photography of people includes straightforward portrait photography through what is called 'social photography'. This also includes weddings, school pictures and most events photography. Finally, the photography of events is the world of published news imagery - images of things that happen. The important difference in this category is that there is a sense of timeliness. These are the images that show what is happening in the world now.

The breaking down of photography into things, people and events is a simple categorisation, but it makes a good starting point in understanding how photography is used and applied. Our specific interest is in where creative input is required in this application. This chapter goes on to look at the different and more complex ways we classify images created for practical rather than purely aesthetic purposes - all forms of applied photography - and the major fields of employment within the creative imaging industry.

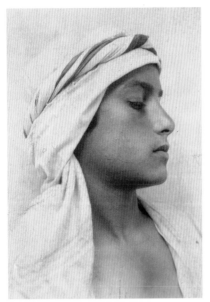
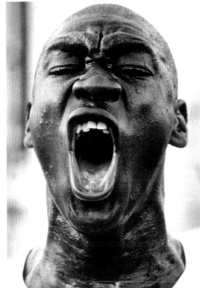

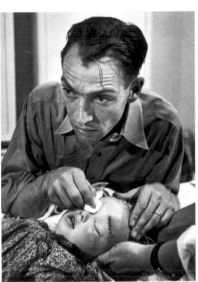

Forms of photography
(Clockwise from top left):
Ashrah by Wilhelm von Gloeden
Yelling Marine by Eddie Adams
Christmas Box – Salvation Army Officer
Man with chef's hat by Bettina Baumgartner
Kevin Pietersen Citizen Advertisement
Country Doctor by Eugene W Smith

Now taken in context (see previous spread), the above images clearly depict the different forms of photography (clockwise from top left): fine art, documentary, promotional, illustration, advertising and photojournalism.

Forms of photography

There are various ways to classify photographic imagery. 'Subject' is just one method of classification. In defining the various forms of photography, one important distinction is to look at the reasons why the image was created. What did the photographer have in mind when they pressed the shutter? What was their intent? What did they intend the image to be or to do?

Part of the answer comes from context – a photograph in a gallery or published in a 'coffee table' volume will probably have been intended as a fine-art image. Not so an image of prepared food published in a magazine. Though we can usefully classify images in this way, there is overlap of use and a considerable amount of cross-fertilisation between commercial and art photography.

Images for self-expression

Taking intent as a method of classification, we can distinguish a category of images created for self-expression and for artistic purposes – photography that is not done primarily for commercial purposes. The extreme of this category would be imagery produced as part of an art therapy workshop, possibly only intended to be seen by the photographer/patient and therapist. There is then the bulk of imagery done to please the self or perhaps just a group of others. That group may be informal (such as a Flickr interest group) or formal (such as images for a camera club competition). The category begins to shade into the commercial world when images are sold for profit. This may, however, be opportunistic and not the original intent behind the creation of the image.

The term 'fine art' tends to confuse rather than clarify the far pole of this category. In America, certainly, there is a good market for photographic fine-art images. These are aesthetically pleasing images intentionally created for sale to individuals and organisations for exhibition and collecting. In Europe, fine art still has a 'high-art' connotation – images created as an expression of self in some artistic endeavour.

◀ Forms of photography
Commercial and advertising
▶ Editorial

Documentary photography

Photography once enjoyed a reputation as the medium of record and evidence – 'the camera never lies'. Scientific and medical photography certainly still aim to provide an accurate record and would not usually be described as 'creative'. The intention is to capture what is there in as clear and unambiguous manner as possible. As such, these fields of professional photography are not the concern of this book.

Documentary photography, however, shares this heritage – the idea of 'truth' and of bearing witness to events. To document means to record. Putting aside modern philosophical debate about the notion of truth in photography, documentary photography covers a range of activities from the political activism of concerned photography to straight photojournalism based on news gathering. The photo essay fits in well here, though the heyday of magazines based on this longer-term, more reflective storytelling form of photography is long passed.

Editorial photography covers images created for publication that do not fall into the 'news' or 'commercial/advertising' categories. Fashion photography and wildlife photography are both large, independent segments of editorial photography while sports photography has a closer connection with photojournalism and the photography of events. Commercial and advertising photography is done to sell products, marking it apart from the 'coverage' aspect of editorial imagery. Promotional work is image-making that sells ideas, agendas or organisational aims rather than products.

Events photography

Events photography is not the same thing as the photography of events. One of the growth areas in modern photography – thanks to the instant nature of digital technology – events photography is more about recording the people attending an event than about recording the event itself. Most society functions will now have an events photographer who will take pictures of the people who attend and sell copies of those images on the night.

Commercial and advertising

It can sometimes be difficult to understand why one photograph in a magazine is described as commercial and one as editorial. The difference lies in looking at who commissioned and paid for the imagery. If the product manufacturer paid for the image, it is commercial; if the magazine commissioned the imagery or it was contributed by a freelance photographer, it is editorial. The description 'commercial photography' covers all types of images created for the purposes of commerce. Commerce is the buying and selling of things on a large scale. So what we are dealing with here is the photography of things - things that are for sale.

Commercial photography

Commercial photography is a large sector in the applied photographic arts and deals with images that require different degrees of creative input. At one extreme there is the formulaic, repetitive world of catalogue photography and the pack shot. At the other end is the apparent glamour and creativity of the motor vehicle advertising industry (fashion photography is such a large subset of commercial photography and it is treated separately, later in this chapter).

Product and pack shot photography is the art of quite literally putting a product 'in the best light' – showing off its qualities to make it desirable through the use of props and setting (for context), and lighting (to reveal its physical qualities, such as colour or texture). Product information is rarely conveyed in these images, which are intended to make us want the product depicted to the point where we will go out and buy it. Advertisements – as the commentator Judith Williamson writes in her book *Decoding Advertisements (Ideology and Meaning in Advertising)* – 'intend to make us feel we are lacking'.

It might be thought that the best background for an advertising photographer would be training in technical photography. However, the need to understand motivation and marketing to be able to create powerful, compelling images for use in advertisements, underlines the need for photographers hoping to work in this field to have as wide an education as possible.

◀ Forms of photography
Commercial and advertising
▶ Editorial

Yellow shoe
Caroline Leeming
(styled by Jessica Richardson)

Hours of careful preparation
and attention to detail, as well
as sound camera and lighting
skills, go into producing
a striking shot like this.

Food as still life

The photography of food is closely
associated with still life. Anything you
learn in the still life studio about lighting
or depth of field equally applies here.
The best food photographers treat
dishes as sculptural pieces, paying
special attention to lighting that will
enhance forms, textures and colour.
They use viewpoint, focus and depth
of field to enhance the appearance
of the food.

Viewpoint is especially important
with food photography. Getting
in low and close makes the food look
more appetising, making the viewer
want to bend down to smell the dish.
Tableware, cutlery and kitchen utensils
can be used to create the right setting
for the food, be it a contemporary
glass and chrome look, or the evening
glow in a rustic kitchen.

Pack shot photography

Pack shot photography produces the kind of images commonly seen in product catalogues or on websites. It relies on the sound application of techniques learned in the still life studio with regards lighting and viewpoint. Though the work may seem repetitive at times – when a client requires one shot of each colour variation of a single product, for instance – there is a need for creativity in the lighting and product arrangement. The precise textures and reflective nature of the product will determine how the product is lit.

Pack shot tabletop set-ups can evolve into elaborate arrangements of reflectors, mirrors, light tents and cutters that block light. These are all used to create precise highlights, controlled reflections, and to reveal the product at its best. As quality is of the essence, it is common to use medium-format digital or large-format cameras with some form of perspective control from tilt/shift lenses or camera movements.

Food photography

Food photography is an especially rewarding specialisation for photographers who enjoy attention to detail. Photographing cooked food can be more pressured than product photography, as the photography and food preparation have to be timed to come together for the shot. You may only have a short time to capture the image once the food is prepared and served. It is no longer acceptable to use cigarette smoke to look like steam from a hot dish or substitute mashed potato for ice cream as was once done! Food photography is not about technical trickery, but creating wholesome and appetising images.

The creativity comes in the choice of settings, lighting, props and in styling the food. Styling may be done by a specialist team member but the photographer will need to understand and advise on how best to show textures and colours.

Food photography may be done on location with portable lighting or by bringing the cook and their ingredients into a suitably equipped studio with a kitchen and food preparation area. Such specialist facilities can be hired. There will often be an art director, a food stylist, the chef and possibly their assistants on the set.

The photographer will almost certainly be involved in creative planning for bigger projects. The art director will set the overall theme, and the stylist will suggest props and choose suitable cutlery and place settings with regard to style and colour.

Once the food is prepared for the camera, there is usually a very limited time in which to capture the required images – if the photographer has technical problems, this could mean the whole team starting the preparation again with a fresh set of ingredients. Confidence and the ability to work under pressure and time constraints are therefore important.

◀ Forms of photography
Commercial and advertising
▶ Editorial

Car photography

Car photography is usually considered one of the most exciting areas of photography to be involved in. Images are created for fine-art purposes as well as for commercial/advertising and editorial purposes. Car photography could involve the rental of the most expensive types of studio, which contain an 'infinity cove'. This enormous, curved back wall can be used to create the appearance of massive space behind the vehicle when correctly lit. Massive softboxes and reflectors are used to create lighting for this most sculptural form of manufacturing design.

Location work is popular, with exciting action images being in demand from magazines and manufacturers alike. Car-to-car photography and special rigs for remote cameras are some of the techniques that deliver these images. Portable and wireless flash have made lighting vehicles on location much easier. Sometimes, however, the shoot requires access to private roads or the closure of publicly accessible areas for the sake of safety.

Many leading commercial car photographers started as staff photographers on car magazines. Students looking for a start in car photography can always begin with custom cars or friends' vehicles to start producing a portfolio of images that will get them a first commission.

Custom car owners are usually only too pleased to have a quality image of their vehicle in exchange for access and the right to photograph it. The same comment applies to classic car owners and clubs who are often poorly served by amateur photographers. Car photography is, however, a massively competitive field as it attracts a great number of aspiring photographers.

**Vantage passion (Aston)
Tim Wallace**

The best car photography demands cutting-edge camera technique, a real passion for the subject and first-class post-production skills – this is commercially commissioned work.

◄ Forms of photography
Commercial and advertising
▶ Editorial

**Welding
Phil Barton,
Laurence Hudghton
Photography**

Good industrial photographers will find attention-grabbing images even in the commonplace industrial scene.

Industrial photography

This area of photography may be more often done by photographers who specialise in scientific imagery. However, when approached by a creative mind, the photography of large-scale industrial complexes and machinery can produce powerfully atmospheric imagery. Some generalist commercial photographers will take on the occasional client from industry just as they would the occasional architectural job.

Promotional work

Promotional work is not quite the same as advertising photography. Though they both try to 'sell' something through their imagery, in the case of promotional photography this tends to be a concept rather than a product. You can immediately see how this can be more difficult to illustrate. Promotional work is often done for charities. It is common therefore for budgets to be limited and for clarity of expression and strong visual ideas to be at a premium.

'Confidence and the ability to work under pressure and time constraints are therefore important.'

Editorial

Editorial photography means 'pictures for publication'. As mentioned in Chapter 2, publication literally means 'to make public'. This is photography commissioned and taken specifically for editorial purposes. Editorial is that part of a magazine or newspaper that is not advertising. It is the reason the magazine exists and the unique selling point it has as a publication to draw a specific body of readers. It is that readership that attracts the advertisers to place their material alongside the editorial content on the pages of the magazine.

Nowadays, the description 'editorial' has a much wider connotation than just print media as it includes some aspects of broadcasting where still images and sequences are often used to underpin television and video productions. There is also a rapidly growing need for editorial photography on the web. Although this unregulated market has frequently shown disregard for issues of image ownership and copyright, it is maturing rapidly as a medium in this respect, with more formal commissioning occurring for web imagery.

The editorial team

Editorial photography may mean working in a strongly team-based part of the creative industry. Though the teams are often fluid and may come together for only one issue of a magazine, there are clear roles and responsibilities. Photographers working for magazines would once be staff members assigned to cover a wide range of topics within a specialist field. This type of employment is becoming increasingly rare as freelance photographers and stock shots are now more often used to cover a magazine's image needs.

There is also a rise in the use of material from sources that would be described in the news media as 'citizen journalists' – public contributions, in other words. Images from this sector are attractive to magazine editors working within tight budgets because the material will be free to use and often the images will be taken by people with privileged access. Technical quality is sadly a secondary issue.

The point of contact with the magazine or newspaper (here we are talking about photography for features and not news) will be either the magazine art editor or the picture editor. A freelance photographer will develop a good working relationship with these individuals if they want future commissions.

There is very little in the way of cold contributing (un-commissioned material) needed by magazines as the images will most often be used to support texts that have already been written or commissioned on specific topics. Occasionally, a magazine will produce image-only features with pictures supported by captions or even something resembling a photo essay, but these opportunities are few and far between.

MARKET garden Graham Oldroy and his sister Janet belong to one of England's foremost rhubarb-growing families their great-grandfather founded E. Oldroyd and Sons in Lofthouse, Yorkshire, at the heart of what is known as the Rhubarb Triangle, formed between Bradford, Wakefield and Leeds.

The technique of 'forcing' rhubarb, to produce tender, bright red sticks with yellow leaves and succulent flesh, was hit upon in 1817. A gardener noticed that a patch of rhubarb accidentally covered with earth was sprouting pink shoots out of season, having been kept warm and dark under the soil. Today, at the Oldroyds' farm in Carlton, rhubarb roots are kept in darkened sheds heated by electric blowers.

Before forcing can begin, however, roots must spend two years growing in the fields cold winters build up vital root nutrients. 'We always hope for nice, frosty weather,' Mr Oldroyd says. 'I can stand more cold than anyone I know.'

Photograph: Mike England.

LIVING
NATIONAL TREASURE
RHUBARB GROWER

Shooting for stock

At one time most freelance editorial photographers used to earn additional money by taking a few extra shots for 'stock. These were images deemed taken outside the terms of a commission and submitted to a stock library. The stock library would then 'loan' images to their clients for use for a fee. Stock photography has become much more complicated with the taking over of smaller and specialist stock libraries by a few big companies, and by the arrival of so-called 'micro-stock' and new types of licensing.

In the past, effectively all stock was rights-managed, which means images were licensed for a particular use at a negotiated/ agreed price. As common today is royalty-free imagery where use is bought outright, either in an individual image or in bulk by subscription or on disk. Royalty-free stock images can be used in any way by a picture editor or designer. As a photographer you need to understand that you now need thousands of images in stock to get any return. You must look very carefully at the type of library, the licenses under which it operates, and the fees it offers to the content providers.

Living National Treasure tear sheet (as featured in *Country Life* magazine) Mike England

The tear sheet is a page or pages torn from a magazine to be used by a photographer for the purposes of showing their work to prospective clients.

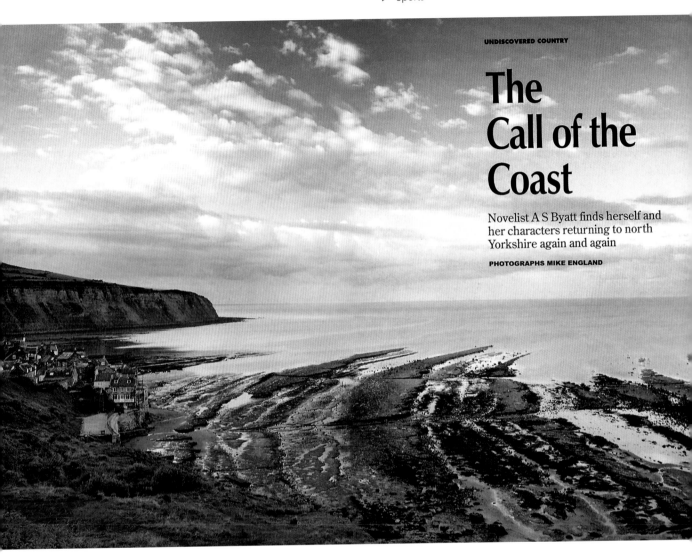

UNDISCOVERED COUNTRY

The Call of the Coast

Novelist A S Byatt finds herself and her characters returning to north Yorkshire again and again

PHOTOGRAPHS MIKE ENGLAND

The Call of the Coast tear sheet (as featured in *Country Homes & Interiors* magazine) Mike England

Magazine editors may commission photographers to illustrate complete articles, such as this one by the writer A S Byatt. Or they may use picture libraries for stock shots.

Freelancing

A freelance photographer should approach the art editor of a magazine they wish to work for with a relevant portfolio. To be able to break into publishing, many photographers have developed writing skills and become magazine contributors in their own right. The formal relationships described here are much more fluid and informal in magazines and fanzines that cover street fashions, urban sports or extreme sports, where you often need to be a participant to get the shots.

Editorial photographers must deliver exactly what is asked for on or before the deadline. Commissions are best in writing. With a written contract, there is no confusion and no room for 'he said, you said' arguments; the terms of verbal contracts can be either unspoken or misunderstood. Be clear about what you are being asked to deliver and in what form. Also be clear about who is doing the asking – do they have the authority to commission you in the first instance?

You need to ask if your expenses will be covered and when you will be paid. Though in many ways the more interesting aspects of the job are the creative side, you must concentrate on getting the professional side of things right at the outset. And that must include a shared understanding of the exact creative approach you will take and how far you can stray from the agreed coverage.

Fees

Payment will often depend on the size of the images used, the quantity and the circulation of the publication. You need to know just what you are selling to the publisher in the way of a license to publish the material. If the publisher wishes to include these images again in another publication (for example, in an annual or to produce an overseas version of the magazine) they will have to renegotiate and pay again.

You should get much more money if you sell world rights. Images should remain the property of the photographer unless a specific contract has been drawn up and signed to transfer ownership to the publisher.

Freelance photographers are strongly advised to become aware of the rate of pay, terms and conditions negotiated by unions and representative bodies, and to consider joining one of these organisations. Collective representation and communication between freelancers can be vital in highlighting companies or individuals that may abuse payment or usage terms. There are easy-to-obtain national codes of practice published by such organisations.

Sports

Sports photography is a massive sector within the news gathering industry. There is a particular demand here for photographers who are not only on top of their own game – technically speaking – but also understand the sport they are covering as if they were a player or participant themselves.
Sports photography also drives camera and lens technology development to a surprising degree. Rather like the motoring innovations that filter down from Formula 1 motor racing, camera technologies are refined and developed here. Image stabilisation and high-speed continuous shooting were pioneered for sports photographers before being made available in consumer cameras and lenses.

Understanding the game and the flow of play is vital for a sports photographer who always needs to be one step ahead. A *New York Times* sports photographer once said: 'If you see it happen in the viewfinder you've missed the shot.' This emphasises the importance of knowing where the play on the field will go and being there with the camera lens before the action happens – good sports photography is a rare combination of anticipation and fast reactions. It's a skill that can be honed by attending amateur events, but one which must have become second nature when attending a national final.

Access

You cannot photograph a match if you are not allowed on the ground. Access means accreditation and accreditation means joining a recognised union or photographic body – carrying an authorised form of identity, such as a press card. Access also means having the appropriate type of equipment to be able to capture the event from the position in the grounds or trackside to which you are given physical access.

As has already been mentioned, sports photography is the proving ground for the long lens and the fast camera. Even if you do get privileged access to the trackside of big sporting events, you will need to have the appropriate equipment to make a telling photograph. For many, this will mean equipment hire and pre-match checking and familiarisation.

Seeing the moment

Before and after the game or race, the aware photographer will move through the crowds in the pit lane or paddock with quite a different type of camera equipment looking for atmosphere and supporting images; the tensions of preparation; the exuberant release of winning; or the dismay of defeat. As often as not, the camera will be turned to face the crowd and not the athletes.

The creativity comes from an understanding of photography as a visual language and conscious assault on the big themes in sport: struggle and endeavour, triumph and defeat. The sports photographer needs an almost preternatural awareness and an ability to 'see the moment' – you need to be someone who not only creates their own opportunities, but also identifies and responds to what many people would call 'luck'.

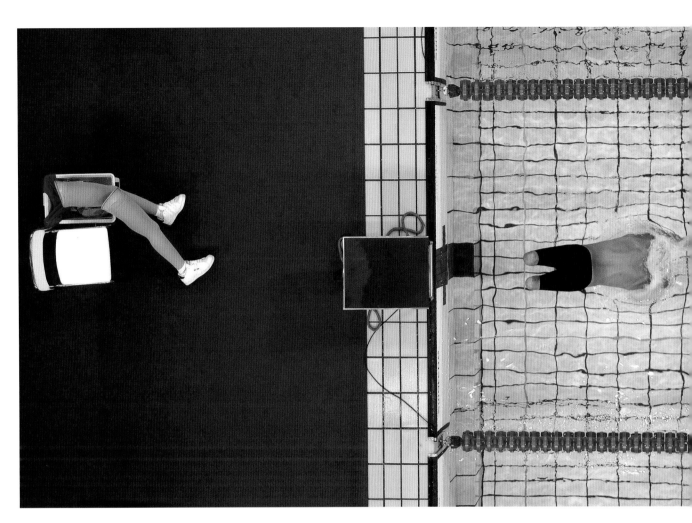

**Spain Xavier Torres, 2004
Summer Paralympics
Bob Martin/Sports Illustrated/
Getty Images**

The moment, the colour palette
and graphic arrangement all
come together to create this
award-winning sports image.

Architectural

Architectural photography deals with all aspects of imagery of the built environment. It is a large enough specialism to have its own subgroups within professional bodies, such as the Architectural Photography Speciality Group of the ASMP (American Society of Media Photographers). Almost always commissioned work, architectural photography may cross a number of the boundaries between advertising and editorial photography, or even social photography, depending on who is commissioning the work and why.

The photographer must sell the experience and feeling as well as depict the scale and physical qualities of the building. The architectural practice commissioning the photography will want to show the concept behind their building – what makes it different and what makes it special – as they will already have site record photography.

The commission is the opportunity for a specialist photographer to work creatively with a team to produce images that may quite literally be expected to sell the big idea behind the building development. The built environment is also about people and there may be a need to show how people interact with the newly created architectural space.

'Selling' the building

Just as the architects will have considered light and how the building fits into its location and environment, the photographer will have to become familiar with the building and location to see how and when it is best lit by natural light. Architectural photography is a demanding field of work as it requires methodical and possibly long-term planning, the ability to liaise and co-operate with professionals in another field, as well as being able to bring a unique and personal style that will show the building at its very best.

The 'sell' may not be to those who are literally buying into the project – it may be for promotional, sometimes even political, purposes. The cost of photography may even be shared between various partnerships: a local planning authority and the architectural practice, or the construction company and the organisation that commissioned the building. Their requirements will have to be reflected in the final portfolio of images.

Planning

Planning is needed to cover weather events and the time of year/day (for lighting and possibly foliage), as well as issues like access, provision of power for lighting, times when the area is free of cars or people (or conversely very busy depending on the requirement), hire of specialist photographic equipment and possibly scaffolding or a 'cherry picker' hydraulic platform for alternative viewpoints.

The number and types of view will be carefully specified in the brief as well as the creative approach to be taken by the photographer. To reduce travel costs and ease access, those commissioning architectural photographers will probably do so locally as production of the final portfolio of images may require many trips to the site. This type of photography is clearly not for everyone – it demands careful planning, technical mastery combined with schedule flexibility, good people skills and strong visual creativity.

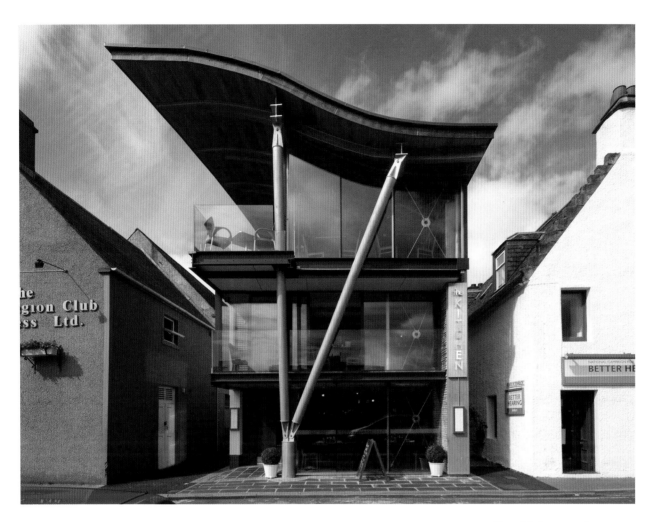

**Riverside Inverness/
Morrison Construction
Paul White**

Good architectural photography
blends technical quality and
precision with an eye for context
and viewpoint.

◄ Architectural

Social

► Wildlife and nature

Social

Social photography is the catch-all title for the photography of people, whether singly or in groups. Wedding and portrait photography were once very formulaic. Portraiture had its formal poses in studios with carefully pre-arranged lighting styles to suit face shapes, character and complexions. Wedding photography often looked more like yearbook photography, with wedding albums containing picture after picture of formal groups with the mood only lightening up for one or two pictures.

Wedding photography

Wedding photography began to shake itself loose from the formality it once had through the introduction of an alternative approach or style known as reportage. Not quite as formal as its journalistic roots, the reportage style of wedding photography treats the wedding as an event to be examined photographically.

Details in unique and intriguing images reveal more about the feelings of the participants than the formality of the occasion. This change in approach meant that wedding photographers often took additional black-and-white images in order to reflect what people thought of as a photojournalistic look. The use of black-and-white film in parallel with colour led Kodak to produce films specifically designed for the wedding photographer who produced black-and-white negatives from film processed in colour developer (chromogenic film), along with the conventional colour films.

The move to digital technology has revolutionised the production of wedding albums as well as the introduction of heavily stylised digital manipulation of wedding imagery. There are creative photographers who specialise in weddings though more often than not, wedding photography is part of a larger photographic business. This could include studio portraiture and child photography in order to produce a financially secure portfolio of activities.

**Bride
Mike Colón**

Modern wedding photography requires a great deal more than getting the family groups right on the wedding day. It may involve the services of stylists and beauticians to create memorable imagery.

Portraiture

Portraiture loosened up in the 1960s and has never looked back. It is now one of the most creative and exciting parts of the photographic industry. Most celebrity portraiture is done for publication, but its style and popularity has lead to a burgeoning market in lifestyle portraiture for individuals and families. The market now demands something much more sophisticated than a conservatively framed and matted picture for the office desk.

Most studios offer a range of exciting display ideas including lightboxes and canvas wraps as well as a conventionally framed and not so conventionally mounted images. Images themselves are more styled and far less formal than of old; families are encouraged to dress casually for the event and to have fun in front of the camera. Photographers are chosen more for their personalities than their technical skills, as it is this aspect of the shoot that will make the pictures unique and saleable.

Focus and exposure issues can almost be dealt with by careful setting up of the camera and lighting beforehand. Some franchises standardise lighting and camera set-up to a large extent, with much of the final image look coming from retouching done by a centralised processing studio. The photographers are more involved in creating that all-important mood and positive atmosphere in the studio.

Some portraiture and lifestyle photography of families is now done on location with the photographer accompanying the family to a favourite place or park. Natural light and on-camera fill flash are the choice – more suited to areas with good and predictable weather. Portraits on location are often referred to as 'environmental portraits' because they show the individual in their natural setting: the gardener in their garden, the horse rider at the stables, etc. This type of portraiture has a lot in common with some forms of editorial photography, but it is intended for sale only to the individual or family who commissions the image – it is not intended for publication.

Hunte family
Venture, Norwich

Studio portraits nowadays involve a much freer approach to picture taking and careful post-production work to create a unique 'look'.

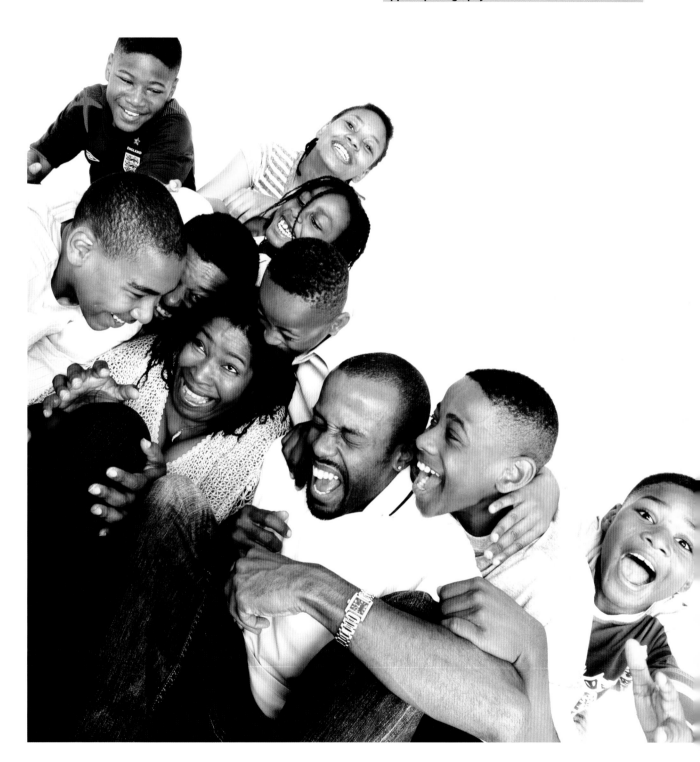

◀ Social
Wildlife and nature
▶ Photojournalism

Child photography

There are certain areas of social photography where the skills of a creative photographer are not required – this would include social imagery produced to a formula such as school photography or mall portraiture. However, if done properly, child photography demands a good deal of creativity from the photographer and special sensitivities towards the ways in which younger children think and play.

The photographic studio could be a very frightening place for a young child. The best child photographers are also psychologists – they put children at ease and they engage with them directly. They do not treat the child as some product to be photographed or spoken to through the parent. They will often make an 'appointment' with the child for their photography, leaving the real booking details to be handled with the parent at another time.

A good photographer will talk to the child about their interests before inviting them along to come and play. The camera may be operated by remote control or an assisting photographer while the child and photographer themselves are apparently engaged in some important play activity. An appreciation of the type of lighting best suited to the young is also required – as is an abundance of patience.

Pet photography

There are some very specialised niches within the overall field of social photography. As pets are part of the family, the rapidly growing area of pet photography could be included here. Animal-handling skills are a vital adjunct for a photographer who specialises in this area and some may even take a veterinary nursing course to feel confident in the care and handling of a wide range of animals. What do you feed an iguana? How warm should your studio be to photograph one? The answers are not something you would find in the average book on photographic technique. As with child photography, the pet photographer needs to have an empathy with animals and an understanding of their behaviour to be able to successfully – and safely – photograph them.

Bereavement photography

While animals and children are an obvious subject for creative photography, there has been a remarkable recent growth in remembrance and bereavement photography in some countries. Though there are wide cultural differences, photography of the recently deceased has been quite a common and accepted practice. The biggest growth area has been in the sensitive depiction of very young children and babies – it is a very specialised niche demanding the highest levels of interpersonal skill and creative sensitivity. It may not appeal to the majority.

Wildlife and nature

In the section on editorial photography, it was mentioned that photographers become magazine contributors in their own right through developing the written word to support their imagery. This is especially true in the field of wildlife and nature photography where stories are more image based than in other magazines. Many wildlife photographers have also turned their photographic skills into earnings by writing in parallel for photography magazines about the equipment and techniques they use in their wildlife photography.

While sport still has its high percentage of full-time professionals, wildlife and natural history photography – the countryside being literally open to all – is a more difficult area for a professional photographer to earn a living. Those looking to make a living photographing in the wild will probably have to adopt a portfolio of activities which may include image-making for specialised picture libraries, team leading or assisting on expeditions and field trips, specialist writing about subjects and technique, public speaking and maybe activities that blur into the commercial art market such as postcard, calendar and fine-print production. Some wildlife photographers even make some of their income from product sponsorship and endorsement.

Technical and practical skills for wildlife photography

Physical stamina – gaining access to some of the most interesting places on earth will be physically demanding. Good wildlife photography demands that you have all your creative intelligence and technical photographic skills on call when you get to your destination.

Good in-camera picture editing and selection skills.

Attention to formal elements and design principles (i.e. composition).

An understanding of political, scientific and conservation issues.

Field craft and outdoor survival skills.

The wildlife photographer's combination of personal attributes was once likened to those needed to cover a major sporting event held on top of a mountain peak!

Crossover of skills

A number of educational establishments have recognised the unusual crossover of skills required from a natural history photographer and there is a growing number of courses available in this area. Some lean towards illustration and include both drawing and photography in their coverage. Others are based on established conservation courses and offer a stronger scientific content, which may include subjects such as ecology, biodiversity, animal behaviour, habitat and conservation.

Because of this wide range of crossover subjects, even within the overall topic of wildlife photography, it would be advisable to check carefully before embarking on such a course as to the precise direction the study will take, and the reliance it may place on a scientific approach and understanding.

**Zebras
Alina Tait**

The best wildlife photographs can be so much more than sharp colourful pictures of wild animals.

Photojournalism

Photojournalism as an occupation has been around since the 1920s. At this time, it became technically possible to reproduce photographs in newspapers and magazines using rotogravure printing. Images could communicate with everyone - even those with limited literacy skills - and illustrated newspapers and photo-based news magazines enjoyed a boom in circulation in the 1920s and 1930s. Imagery accompanying news items became timelier and newspapers began to employ photographers to cover events. Where once a news item could only be accompanied by existing photography or illustrations from the newspaper archives, it became possible to illustrate current news events with a set of specifically taken photographic images.

Since its first use, the term 'photojournalist' has undergone a progressive shift in meaning. Originally it referred to someone who reported the news in pictures rather than just words - the reporter with a camera. Over time, photojournalism began to be taught in colleges and universities, taking on board the broader influences of economics, history, language and politics. It now draws on even wider influences from the fine-art world. Nowadays, you are almost more likely to find social documentary 'reporting' in published book form or in a gallery exhibition than in the news media.

**Gas pipeline explosion
Akintunde Akinleye**

A man washes the soot from his face at the scene of a gas pipeline explosion near Nigeria's commercial capital Lagos in December 2006 - stunning imagery and news content.

**Papua New Guinea
Rick Rycroft**

The photojournalist may
have more time to explore
issues and compose images
than the events driven,
hard-news photographer.

News photography

True news photography is events driven. The education
enjoyed by press photographers means they will use
creative visual language in their work whenever possible,
as the event itself may dictate the possibilities. News
photography tends to depict or bear witness to the event.
There is an immediacy and timeliness about the images
that limits the degree of creative interpretation, which is
either required or acceptable. This is sometimes referred
to as 'hard' news.

Photojournalists, on the other hand, are less witnesses
and observers and more interpreters. While a news
image will often answer the journalist's questions –
who, what, why, where and when – in a single image,
a photojournalistic image may leave some questions
intentionally unanswered and probably ask as many
of the viewer as their imagery seems to answer.

One of the key debates in photojournalism has long
been how appropriate a creative approach is and
where to draw the line between reportage and creativity.
The use of posed, staged or re-staged photographs
throws up ethical questions and begins to pick at the
whole issue of where photojournalistic practice now
sits in a media-savvy, image-aware world.

**'One of the key debates in
photojournalism has long been
where to draw the line between
reportage and creativity.'**

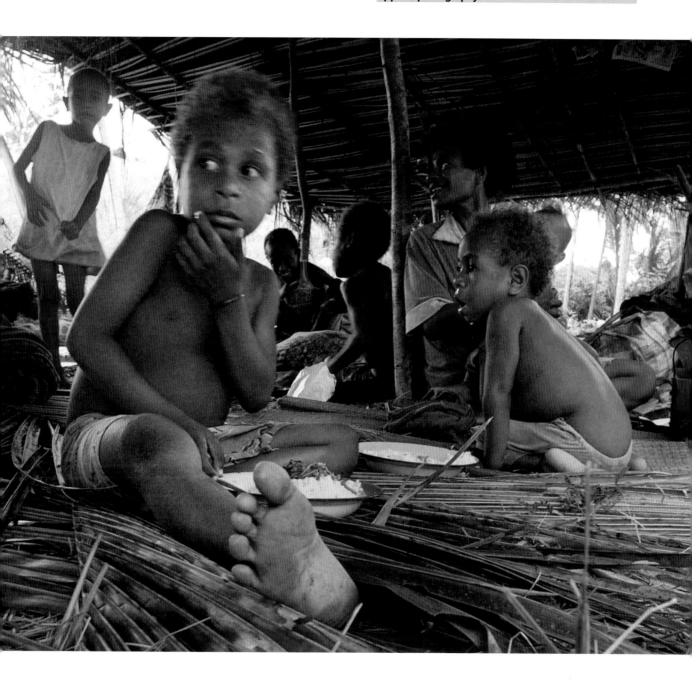

The images on this spread are from the photo essay 'Hidden Half: Women in Afghanistan' by Canadian photojournalist Lana Šlezic.

The photographer travelled through Afghanistan to capture and document these images. These powerful pictures are all connected – they tell a story and are based on a focused theme.

For more information on this photo essay please visit: www.motherjones.com/photoessays.

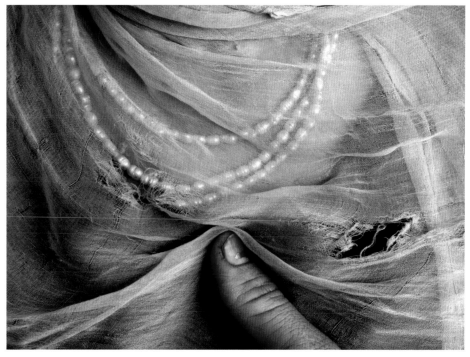

Afghan prostitute

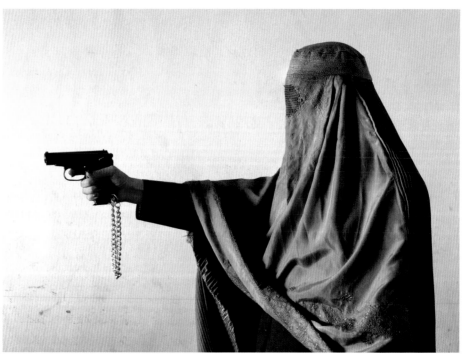

Malalai Kakar

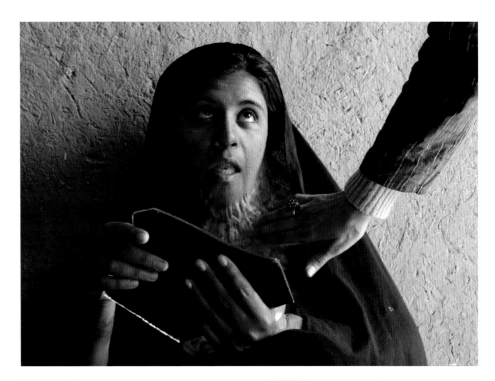

Zahra

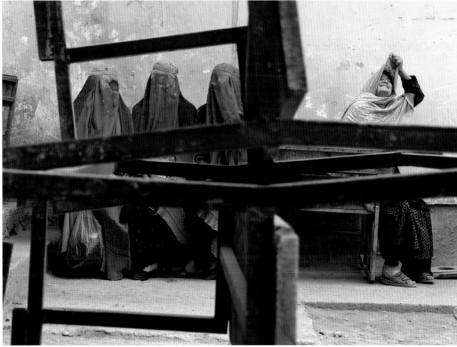

Election day

Photo essays

A photojournalist can in one sense be thought of as a news reporter, using a camera instead of a notebook and pen. However, there is a more considered form of photojournalism where instead of a news item (picture), a complete essay or story is produced: the picture story or photo essay. Photo essays are more commonly found in galleries and published in books. Where a photojournalist may sum-up the story in just one compelling image, the photo essayist – sometimes called a documentary photographer – will produce a series of connected images based on one theme. The photo essay is a considered body of work that may be the result of a self-initiated project or commission. It is a longer-term project than simple news coverage and may take many weeks or years of preparation and photography to complete.

Photo essay – structure

The photo essay needs to have a structure, just like its printed counterpart. It first needs a formal structure to establish the subject, expand on the theme, explore aspects in detail and come to a conclusion. The sequence of images will almost certainly not be in the actual order in which they were taken. Picture editors expect a clear structure and will be looking for a wide establishing shot: close-ups of activity, a decisive event or moment, portraits (headshots) and a concluding image. To see how this approach tells powerful stories, look at one of photo essayist Eugene W. Smith's compelling *Life* magazine photo essays: 'Country Doctor' and 'Nurse Midwife' (reprinted in the monograph 'Let Truth Be the Prejudice').

Citizen journalists

There are technological and social pressures that are changing the role of the photojournalist forever. First is the rise of the so-called citizen journalist. Often, as news breaks, there is no professional journalist available to report events and members of the general public, who just happen to be on the spot, supply timely images. These citizen journalists capture their images on compact cameras and mobile phones, which permit the images to be instantly uploaded and available on news websites and on television.

Quality is of little or no importance. Money very rarely changes hands as members of the public are often only too happy to have their 'fifteen minutes of fame'. In response, the professional is compelled to do a different job altogether and to cover the story from another angle, looking deeper for new revelations and back stories. It is often the quality of their research that leads the photojournalist to a new angle on an existing story.

New technology

A new generation of D-SLR cameras shows the way photojournalism is going. Today's bigger corporations no longer just print newspapers, but have a much wider reach across the new distribution media. This will undoubtedly include the web and television. Those contributing imagery to the media will be expected to have it in a form suitable for web log video inserts as well as print, and possibly broadcast television.

The latest D-SLRs feature high-quality video recording in a still camera that is clearly aimed at being a professional photographer's second camera or back-up body. No longer are separate stills photographers and television news crews despatched to cover a breaking news story – one photographer/videographer will be expected to bring back all the goods. And edit their own material. And caption it. Guaranteed employment in the future will mean having a portfolio of skills and abilities, not just an eye for a good news picture.

Image manipulation

Computer image editing has produced a whole new area of ethical issues in the world of photojournalism. How far can removal of blemishes and technical enhancement go before it becomes misleading image manipulation? Photojournalists who have tampered with image content in order to improve the look or to strengthen their story – however valid – have usually paid with their job.

In 2003, this was the fate of a *Los Angeles Times* staff photographer who produced an image of a British soldier in Basra, Iraq, gesturing for a father carrying his child to get down and take cover. Editors discovered the image was a composite of two frames and had been created by the photographer to strengthen both the composition and message. Creativity in the camera is one thing; creating an image of something that did not in reality happen is quite another.

'It is often the quality of their research that leads the photojournalist to a new angle on an existing story.'

Fashion
Caroline Leeming
(styled by Amy Bannerman)

Great fashion shots are often
the result of close teamwork
between model, stylist and
photographer.

Fashion

Fashion photography is a subset of both commercial and editorial photography as it is commissioned and paid for by both the fashion labels for advertisement purposes and by fashion magazines. It is a large subject in its own right and one employing specialist creative photographers who do little else. However, it is probably the most competitive arena in paid-for photography. Those who make it in fashion photography usually have a unique combination of talents, the most important ones being confidence, the ability to refresh one's style, and keeping in touch with social change and trends in both fashion and photography.

Fashion photographers must be close observers of the trends in fashion and society, they must be able to put these into context and use them to power their imaginations. They must be technically adventurous, capable and confident. Most importantly, they need good people skills to get the best from models and the creative teams with whom they will work. Finally, they need a good head for business and skill in negotiating – or a first-class agent (see Chapter 5). They also need to be persistent to a fault.

Networking and contacts

A fashion photographer's first contacts are often made through their network of friends and associates from college. Fashion is a people-centred industry and good contacts in the first instance, along with trust between photographer and client, are essential. There is also a symbiotic way in which a good photographer can enhance a designer's reputation and vice versa.

Photographers who work well in the portrait studio often work well with fashion models as it is a similar sensitivity that produces a good working relationship between the model and photographer. The other essential members of the fashion team are the professional stylists for clothing, hair and make-up. Money must be budgeted and spent on the best stylists.

Get a website, get a portfolio, produce postcards and comp cards (your name or logo, plus a selection of images), pick up the phone and talk to people; go out and look for work and follow up each and every lead. Keep abreast of what is happening on the equipment front. Keep in touch with changes in the magazines and advertising. Look at the best techniques and styles, and then better them. And remember that however many images you have taken it is never enough.

Equipment, studio and location

Studio lighting is becoming increasingly sophisticated and, like the digital camera, is often computer controlled through dedicated software. Increasing sophistication of both cameras and lighting equipment often means that fashion photographers will be hiring equipment by the day rather than buying it outright.

Location fashion photography can be exciting, but technically demanding. In contrast, studio work is more controlled. Powerful studio lighting is now available from rechargeable battery packs for location use – much of it available to hire from specialist photographic hire companies. As soon as you move out of the studio, you begin to lose control of things such as white balance and light levels. Many fashion photographers use arrays of wireless flashguns to create very lightweight, portable 'studios'. Shooting on location – even for a student fashion photographer getting together a portfolio – may need permissions and careful risk assessment. However exciting the prospect of shooting outdoors may be, you must keep within the local laws and keep your co-workers safe.

Leave nothing to chance, so test, test and test again – wherever there is a technical variable, try to control it. If you can, try to work with models you know.
There is little worse than finding the absence of chemistry between photographer and model once you are certain of the style, artistic approach and have all issues of photographic technique locked down.

Bloom while things are dying
Lincoln Luke Chanis

Location fashion shoots can deliver stunning images and offer opportunities not available in the studio, but nothing can be left to chance.

**Valentino Haute Couture
Spring Summer 2008
Catwalking**

Catwalk (runway)
photography is one of
the toughest assignments
in fashion photography,
requiring a fast camera
and an even faster eye.

The catwalk

Photographing models on the catwalk (runway) is a skill in itself. The biggest surprise for those covering a fashion show for the first time is the speed demanded of the photographer and the sheer number of images required to get everything right in just one frame. The need to keep photographing in bursts just to get one good image puts an amazing demand on batteries – especially if fill flash is being used. The camera must be capable of shooting and storing long image bursts. There is little use in being able to shoot eight frames in a second if the camera then takes ten seconds to write the buffered images to the memory card.

Choice of lens will depend on the venue and possibly the client's requirements. What will be important is choosing a viewpoint that provides good backgrounds without clutter or distracting detail. Long focal-length lenses at wide aperture work well in this regard, but demand critical focusing. The speed with which you can zoom will also make a big difference to the way you work – beginners find it very hard to get a good clear head shot among the full-length images as they cannot work quickly enough to zoom, frame and lock focus.

Only photographers working for the fashion house will have any say in the way the models are lit. Often, the venue lighting will be more powerful than any flash you can bring or provide power for, while spotlights can be a problem. Wireless flash is good for fill light, but it may be interfered with by other photographers' flash equipment. Anyone using flash has to remember that the recycling time will limit the speed with which they can take pictures. Do not underestimate the need for big battery packs and wide aperture lenses on rapid-fire bodies – the professionals use this equipment because they need to.

Coverage

The coverage you will need for each model/outfit will depend on the client's requirement, but you may be asked for a full body shot and possibly headshots or particular detailed shots of accessories. Anticipate the model's arrival and get their first expression as they enter the catwalk; anticipate their stride, look for good facial expressions and open confident poses.

Models will often pause or stand at the end of the runway. You will probably need to get ten or more shots of each model to be confident of getting one or two useable images. Photographers are often assigned to a designated spot at the venue, which may not be of their choosing. Be ready, too, for the unexpected newsworthy event that gives you an image which will sell outside the fashion world. A supermodel breaking her heel and falling has more than once made it from the fashion pages to the front page!

Working within photography

A large proportion of the people employed in photography do not work as photographers. Each year, there are thousands of students who graduate with a first degree in photography, yet there are probably only jobs for a few hundred professional photographers. There are of course those who provide services for photographers, sorting out cameras, computers and prints. However, the focus of this section is on people working creatively within the industry, but not necessarily as photographers.

Gallery of Photography, Dublin
Ros Kavanagh

Galleries and sales rooms can provide jobs for trained photographers who may not want a career behind the camera.

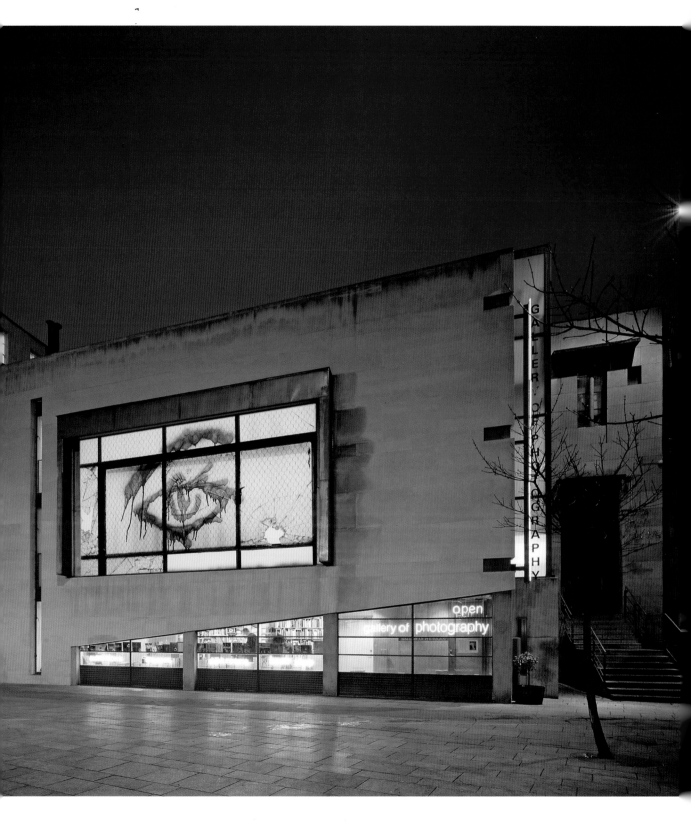

Support staff

Each major area of creative applied photography will have its specialist support staff – food stylists and make-up artists who will need to know what a photographer requires and how to work with products, models, sets and professional photographers. Photographers rely on the creativity of these individuals to create the quality of the finished image. There are also the assisting photographers and digital assistants who work alongside the photographer to achieve the shot and bring the job in on budget.

There are those who realise that they will be far happier and better suited to working full time in an assisting role. Their photographic creativity may find its outlet in personal work done purely for self-expression, without the unwelcome pressures of commercial considerations. This is a judgement the individual must make, along with finding an acceptable balance between their ambition and talents.

Creative retouching

Digital photography made armies of print and transparency retouchers redundant, replacing them with a few Photoshop 'wizards'. However, digital photography is now throwing up its own specialisms and demanding more and more people at workstations rather than behind the camera. Creative retouching in a commercial context is a different skill from the creation of complex, photo-based digital artwork.

As has been seen in many areas, the creative industries employ people right across the skill and creativity range. There are retouchers who specialise only in skin retouching for fashion portraiture. Their specialist skills are very much in demand as these days images rarely get into print without extensive digital cleaning-up – and this is not something that every photographer wishes to do him or herself.

'Buying a Nikon doesn't make you a photographer. It makes you a Nikon owner.'

Picture editors and picture researchers

The magazine, book and newspaper industries employ a good number of photographers who prefer to work within the organisation on the picture desk rather than as a contributor or freelance photographer. The job of a picture editor – sometimes called a photo editor – is to select images for publication from those submitted.

A photographer may submit a portfolio or contact sheets full of images, but the magazine only has space for a handful of those. It is the picture editor's job to select those images that work best together and yet fulfil different roles on the page, such as the establishing shot and detail shots. The job usually goes much wider to include creating or promoting a particular style of photography for the publication, commissioning imagery from freelancers and working with the budgetary constraints of the publication. Picture editors usually have the last word in style and standards.

Freelance picture editors often bring some of the skills of a picture researcher in being able to hunt out and obtain the rights for publication to existing imagery. Picture editors will be employed on a freelance or short-term contract basis by publications that do not have a regular schedule – this would include exhibition catalogues for museums and art galleries, or similar projects for companies or institutions. Picture researchers – as opposed to picture editors – tend to have wider art experience than pure photography as they will be involved in art and illustration, as well as photography.

Skill sets

A recent newspaper advertisement for a photo editor gave the following job description: 'requires good experience of Web CMS and photo editing software...must be able to source and choose appropriate images, edit them according to the site's specification and write compelling headlines and captions to accompany them'. From the outset you would need to know that CMS stands for 'Content Management System' (how content is added to and changed on a website). The job specification stressed strong visual ability and technical skills with software but also good literacy skills. This underlies the current thinking that entrants to graduate photography courses are better suited to education and employment with good literacy and visual literacy skills – the technical side of photography can always be taught.

**Fernanda Valverde retouches
a collodion negative using
19th-century techniques
George Eastman House**

Jobs and professions within the
photographic industry need not
always mean working behind
the lens. Other specialist areas
include conservation,
cataloguing and archiving.

Conservation and vintage prints

Photography has become a much more established art form with its own recognised history. As such, galleries specialising in photography for both display and sales have increased and require graduates with knowledge of the history of photography and of some of the conservation issues surrounding the handling and ownership of historical photographic prints. There are two quite separate career paths here. One involves conservation and the understanding and preparation of materials concerning the history of photography – employment may be either in a specialist context, such as an auction house or fine art gallery, or in public museums or art galleries. The other route is the more commercial, relating to the growing market in fine art and vintage prints.

Cataloguing and archiving

Stock libraries always took a number of photography graduates who enjoyed cataloguing and key wording, as well as dealing with contributing specialist photographers. This need for photographic specialists has reduced considerably with the advent of micro stock and the submission of stock key worded by the contributors. As in all areas, salaried jobs will become harder to find as they are replaced by freelancer and short-term contracts. Most of the 'safe' salaried jobs in photography are not found in the creative industries at all, but in the armed forces or police service.

There is of course the possibility of going back into the education system to teach the next generation of photographers. It is more common that colleges and universities look to employ practising photographers, with many teaching posts being part-time or fractional posts where continued employment elsewhere is expected.

'Salaried jobs will become harder to find and will be replaced by freelance and short-term contracts.'

3

Applied photography

Professionalism

Professionalism (n.) the skill and competence of a highly trained individual engaged in a specific activity as a main paid occupation

The brief

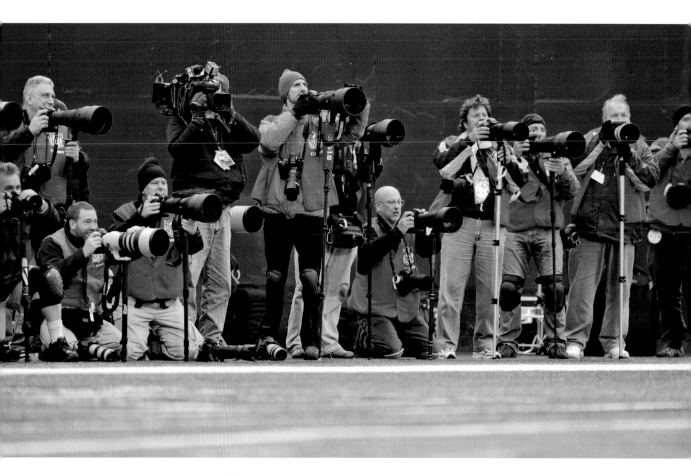

**Baltimore Ravens
vs
New York Giants
Rob Tringali/Getty Images
Sports**

Becoming a professional
photographer means being
an accredited member of
the press and gaining access
to a range of very expensive
camera equipment.

What makes someone a professional? In simple terms it means that you undertake an activity for money. To be brutally honest, photography is not a profession – a profession is regarded as having a long training period leading to a formal qualification, while professional practice is usually the giving of expert advice rather than creating tangible goods such as photographs. Traditional professions are knowledge based. In truth, photography is a business not a profession. However, because you are paid to do a job, there are certain standards of behaviour and competence that are expected. Someone describing himself or herself as a 'professional' photographer is expected to act in a professional manner, to keep to deadlines and to produce work along the lines agreed during meetings with the client. Working photographers are often bound by legal contracts regarding both the delivery of work and payment.

A full-time career professional is someone lucky enough to have been working in photography every day since they graduated. This is the career profile many aspire to. In reality, only a tiny proportion of photographers ever achieve this status. Photography has been de-skilled. This means that as most people now own and know how to use a camera and are capable of producing fairly decent results, images are often taken by 'someone in marketing' to save on the cost of a professional photographer. The market is also full of amateurs who have full-time jobs but spend every other waking hour working at weddings, events photography or shooting images for stock. Few photographers can make a full-time living from photography, but that should not stop you trying.

People seem to think that using a certain cost and quality of camera equipment mysteriously bestows a degree of professionalism. It is as if spending a lot of money on equipment somehow guarantees a professional result. On the contrary, one commentator once wryly defined the professional camera as 'any camera that makes its user money'. There is a good deal of truth in that statement. Camera manufacturers rely on the kudos that owning a 'professional quality' kit brings. What really marks out a camera as suitable for professionals is not necessarily advanced imaging features, but ruggedness and longevity. It is the ability to bring back a picture in sometimes physically difficult conditions – and to go on doing this day in and day out – that makes a camera suitable for professional use.

It is surprising how many professionals do not own their own equipment but will rent cameras, and especially lenses, for specific jobs. There is a thriving camera equipment rental market for professionals who really do see their equipment as a tool to get a job done. With the useful professional life of a digital camera now being only a few years, it becomes less of an advantage to own photographic equipment as its costs will have to be amortised over just a few years.

Getting an education

There are some working photographers with no formal education in photography. There are even those who say you do not need a formal education – your portfolio alone will get you jobs. These observations are true but they apply only to the very lucky, the very talented and the very persistent. The rest of us need a hand-up.

Formal education gives you time and freedom to experiment and to develop your personal style. Many courses allow and encourage students to try many different genres and styles of photography. You may want to work in fashion but a short exploration of social documentary, its approach and issues, may help your ambitions in fashion and open up new ideas – it may even persuade you to take up social documentary photography. With photography, you never know until you have tried it. Cross fertilisation of styles from other genres, of techniques and approaches is the lifeblood of the visual arts. Attending a formal course also allows you to network and to work within creative teams. Working with people on other courses and assisting students in the years above you will help fast track your own technical and artistic development.

Selecting a course

So how does one choose a suitable course? There is a full spectrum – ranging from very technical, commercially orientated courses to fine-art courses that major in critical analysis. Look for a course where you are comfortable with the balance of technical and academic content. You need to interview the college or university just as they will interview you. Draw up a shortlist of things that matter to you. You will have the opportunity to ask these questions at an open day, possibly during interview. Ask, too, about work experience and placement and how this is handled as part of the course. Open days are an ideal opportunity to visit a college or university in an informal atmosphere, without commitment. Talk to students already taking the course you want to apply for and ask what study and life are like for them. Look around the facilities. Are the computers and software up to date? Is there a range of equipment available? Does the campus maintain traditional darkrooms?

The portfolio

Applying will mean submitting a portfolio – printed or on CD/DVD – probably in person. It surprises some that fellow photography students have been given places on the strength of a portfolio of drawings only. What counts is your visual literacy – the ability to read imagery and communicate visually. If you are already studying photography at school or college and have a portfolio of coursework, do not rely on just those images. Interviewers will wish to discuss the images you take for yourself, your motivations and what makes you interested in photography.

Having graduated, many students want to take their academic studies further into a Masters programme. Certainly, this may be helpful if you intend to teach. Colleges and universities produce many more 'photographers' than there are jobs. It is important to be prepared for the fact that you may work around photography after your education, but not necessarily as a photographer. The best colleges will prepare you for life on the outside with tailored advice on career progression. You should graduate with a portfolio strong enough to take you into your first assignment.

'The best colleges will prepare you for life on the outside.'

Things to consider when selecting a course

What do you want from your education?

Are you happier in smaller classes?

What is the balance of written and portfolio work?

What range of equipment will you be allowed to use?

How well stocked with photography books is the campus library?

Are work experience and placement part of the course? If so, how are these aspects handled within the course?

Are the computers and software up to date?

Is there a range of equipment available?

Does the campus maintain traditional darkrooms?

◀ Getting an education
Learning as an assisting photographer
▶ Getting work

Learning as an assisting photographer

As a way of supplementing your knowledge of the business, there is no better way than working as an assisting photographer. Assisting is not really a job for those who have no prior experience of the speed and intensity of studio or location photography. It is more suitable for undergraduate students who, already having some experience of their own in college studios, want to widen their experience by working with professionals.

Assisting is usually done on a job-by-job basis. The arrangements are often made at short notice and verbally. You will need to know the time and location; if any special prior knowledge is expected or required; the basic fee; and how expenses will be covered. You may wish to negotiate a cancellation fee to give you some cover if the job falls through. It is a cruel fact for those not living in the biggest cities that there are few opportunities in the provinces and that personal networks do not reach that far. There are one or two networking websites for assisting photographers, but be very careful that they are not just after money for 'registration' or 'training'. Check out the experiences of someone who has already joined if you can. The skills you will need are patience, persistence and anticipation.

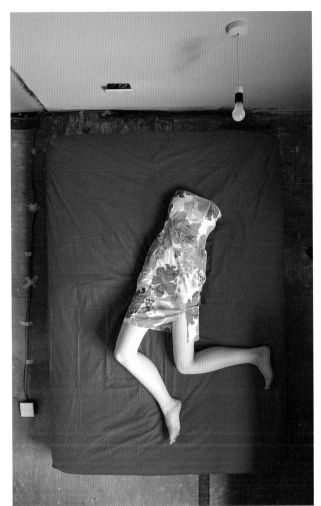
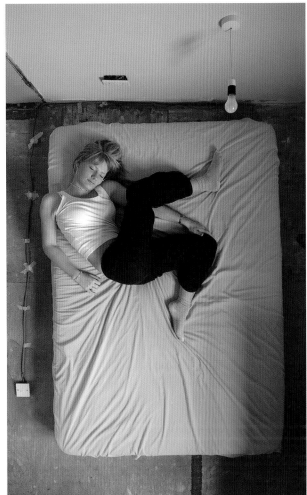

**Bed experiment
Colin Demain**

A formal education gives you the time to experiment with new equipment, new ideas or to try out editing techniques, helping you polish and perfect your work. One of these images was chosen as a poster and ad campaign for the BA Honours Photography course where this student studied.

Work opportunities

Though you may see assisting as a waypoint on your own career, there are those who turn assisting into a full-time job – especially when their personal photographic work would not support them financially. There may be opportunities to build your own portfolio, but do not bank on this and do not go into the assisting role assuming you will be able to create your own work in downtime. The career of digital technician/assistant grew out of the fact that many recently graduated assisting photographers had far wider experience of digital kit and software than some of the established photographers they were assisting.

There are possibilities of job placements where you would spend a longer period with a professional photographer on a range of jobs. You would probably see a much wider range of business activity too, including the less glamorous but important side of the business, such as invoicing and chasing payments. It is likely that any job placement will be unpaid. Many students see job placements as one of the main opportunities of their degree course, but are often surprised when told that it is to be self-negotiated. The college or university will support and sponsor the student, but it is the student who must find a suitable placement and negotiate terms. The best educational establishments will encourage this as part of a professional practice module, usually in the second year of undergraduate study, and will expect a written report. It may be difficult to find a professional prepared to take on a 'learner', but you will have to sell your willingness to learn a wide range of skills and show that you have some photographic competence.

It is possible to get experience through a so-called 'internship' – these are unpaid roles. They cannot honestly be recommended. That said, many people do work unpaid in exchange for experience, though you need to be very clear in your own mind just what benefits you are going to get in exchange for the long hours, hard work and no money. In a job placement, you are not paid to watch the job; as an intern you are not paid to do the job.

'Assisting is not really a job for those who have no prior experience.'

Photographer and assistant on a Hawaiian beach
Kenneth Sponsler (top)

Photographer and assistant at Blue Ridge Parkway
Bonita R Cheshier (bottom)

Working as an assisting photographer may seem to involve a lot of fetching and carrying, but the opportunity is there to see how professionals make their images.

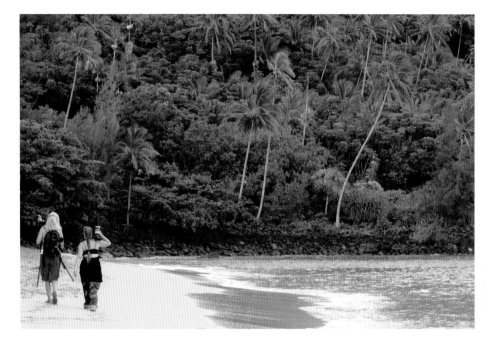

Male cancer
Anna Griffiths

A strong graduating portfolio
like this – promoting the
awareness of male cancers
(based on a blue ribbon,
like the pink ribbon for breast
cancer) – is a way to open doors
in the job market.

Getting work

Full of ideas and technical skill, you will want to start earning money from your photography. There is very little money to be made from selling your own work – certainly not before you establish a reputation or style. The only two routes into making money from your personal images are through fine-art sales or through selling stock photography. The internet has blown these markets wide open. Anyone can offer an image for sale through a website, the difficulty is in first getting enough people to see your work and secondly, enough people to buy it.

The same holds true for stock photography – there are now so many people producing images for stock that the model of a professional photographer creating images for sale no longer holds. You will be fighting an army of amateurs, each selling just a few images but who together take the oxygen out of the market for someone seeking to make a full-time living. To compete and make a living, you will need tens of thousands of quality images – that is not going to happen overnight. The only solution is to specialise. Look for niches that are unexploited – do not try to compete in the mass market. Shoot for stock on the back of your other work.

Other work options

Another way to make money from photography is to be hired to take pictures for other people. That means finding people who need pictures taking and who are prepared to pay money for it. Sadly, there are plenty of individuals and organisations that want and need images, but do not wish to employ a professional photographer to produce them.

If you want to join the relatively small number of photographers who make a living exclusively from photography, you will have to up your game. Key words here are 'networking' and 'targeted'. You cannot pretend any more to buy a studio with your name outside and take an advert in the telephone book waiting for the customers to come flocking in. They won't.

The network of friends and colleagues you make at college will last through the early years of employment. People will first turn to those they know for help – when a recent graduate gets a paid-for job, they are going to turn to their contact book and college friends for support as production assistants and assisting photographers. You need to find the loop and remain within it, sometimes working with friends, sometimes employing them.

Do remember that you are not going to get work as a main photographer from other photographers. It is much more likely you will be asked to produce work for graphic designers, artists and architects, so make your networks wider than just your own department at college. The best educational establishments encourage their photography students to work with web designers, illustrators and others on undergraduate projects for just this reason.

Hiring vs buying

Once you have started to earn money from your photography, the temptation is to buy all that equipment you dreamed of owning. A word of caution – you may be better off hiring rather than buying. And though it seems the hardest thing to do – make provision for taxation by putting away a portion of your earnings as savings to cover national or local taxes. The first tax demand can then be dealt with comfortably and confidently without it being a financial threat to your new enterprise. You can always treat yourself from what you have left over from your tax provision.

Portfolios

A portfolio is a set of photographs that shows off your skills to prospective clients. The portfolio is, in other words, a photographer's shop window. Putting together a portfolio can be a difficult and daunting task.

The best advice I ever heard was given by Mike Johnston, the veteran photo magazine writer and editor: 'First off, remember that you're not dead'. So many people starting out attempt to produce a portfolio that covers everything they have ever done, as if their portfolio were a retrospective. Nor do you have to produce only one portfolio - if you have two strong styles, or have work from both fashion and sports, produce targeted portfolios for each specific market.

You love all the work you have done, so how can you possibly pick out the best imagery for your portfolio? You can meet an equal number of aspiring professional photographers who say they have not yet taken anything good enough for a portfolio. Both parties are wrong! Depending on your feelings, you can approach getting together a portfolio in one of two ways - building it up or cutting it down. Mike Johnston refers to these as the 'building around the hits' and the 'culling' methods.

Building

You may find the easiest way to produce a portfolio is to start showing around small sections of your work to people you have met - possibly while you were working as an assisting photographer. This helps you see what works for other people and though it can be informative, the advice of other photographers is not always what you need. Try instead to get feedback from the professional designers, art directors or even people you may have met through a model agency as they will usually be prepared to give you some tips and honest suggestions. The advice of the end-users of imagery is more important than getting the possibly biased input from other image creators.

Building around the hits means you start with the images that get strong feedback. The catch here is that your best images may not be of similar subjects or done using the same photographic techniques. Colleges and universities constantly use the phrase 'a body of work' and students are expected to produce sets of similarly styled, consistently produced images for tutorials.

The key in choosing a hit-based portfolio is to keep the distance between differences roughly even. For instance, don't include a handful of low-key black-and-white flower images among a range of portraits done using different photographic techniques. If you are a generalist, show a representative cross-section of your work in both subject and style - celebrate the fact, don't try to hide it.

'Building around the hits means you start with the images that get strong feedback.'

Black book
Mike Davies/Plastic Sandwich

The physical presentation of your portfolio of work matters – quality work deserves a quality print book.

Culling

The culling method relies on starting out with a good number of images that you then reduce by rejecting the weakest. You might wish to choose only the one best image from each session or choose to theme the selection – the strategy is up to you. One student photographer produced miniature prints of possible portfolio images and carried between 80 and 100 of them around in a small slipcase. Almost everyone he met was asked to sort out the images they liked best, almost like dealing cards. He recorded 'picks' on the back of each mini print. The images receiving the most feedback were refined to produce a strong final portfolio. If you try this method, be prepared to lose some personal favourites early in the process – every photographer tends to be too close to their own work.

Producing images

So where does all the work come from for your portfolio? If you have been a student, you will have already produced a series of images across styles and genres. These will open doors, but will only take you so far as clients will be looking for successful, commercial work. If you have work as an assisting photographer you might be able to shoot some of your own work on the same set, even with the same models, but you need to keep your look distinctly different from that used by the main photographer to avoid any suggestions of passing off. Some student photographers offer to work for charities and produce commercial quality images that not only benefit the charity, but also can be used in a portfolio.

If you need to strengthen your portfolio, the only option may be to rent a studio space and produce some quality images around a self-set brief. Be very focused and clear about what you need to produce and who will be looking at these images. Trawling through your old images looking for pictures to plug the gaps in your portfolio will weaken its overall effect.

Presentation

Once you have the images together they must be printed using the same technique for consistency and preferably to the same size and format. Your physical portfolio must impress from the outset. It should not have so few prints as to suggest you got lucky once or twice, but on the other hand, it must not outstay its welcome. It should not contain too many prints. If you want numbers: no more than 40 and no less than 12 prints. The prints must ooze quality. If they get marked or damaged at all, they must be replaced as your portfolio needs to appear pristine for every person who looks at it. Quality means both content and technical/print quality. There should be no apologies and no embarrassed explanations when you present your work.

A quality leather binder with the option to change and substitute pages is an ideal presentation method, especially if you have to send or leave your portfolio with an art director or client for any period of time. If you are making the presentation yourself, and know you will be taking your work away with you, a set of matted prints in a quality box put up one by one on a collapsible easel is a possibility. If you only have transparencies, do not rely on there being a projector or even light box to use – if you have to, take your own. Leaving a CD or DVD copy of your portfolio behind with an art director can impress. However, do not rely on a computer presentation of your portfolio images as a first option, unless specifically asked to do so. The quality of your photography cannot always be assessed from a screen-resolution image.

When presenting your portfolio in person, be proud of your images and talk about them positively. If you have to apologise or explain away some aspect of an image, it should not have been included in the first place. You would be surprised at the favourable reaction you can create by presenting your work in a positive but realistic manner. Even if you do not get the job this time, you may well be asked to present again once you have more experience. You will not be successful at getting work every time you show your portfolio but always ask for feedback, pointers and positive criticism. Take more pictures, fine-tune your portfolio and try again.

Graduate exhibition, London
Blackpool and
The Fylde College
Paul Britwell

Your graduation exhibition
is an important opportunity
to showcase your work – invite
people you would like
to impress as well as friends,
family and those you might
wish to thank.

◀ Portfolios
Marketing yourself
▶ Representation and agents

Marketing yourself

For students, the business of promoting yourself will start with your graduation show. This is an opportunity to show the kind of work of which you are capable not only to the general public, but also to potential clients and possibly employers.

The graduation show or exhibition of your final major work usually has a private viewing for selected guests. It is important to invite not only those you would like to thank, but also to invite those who might play an important role in your future. Agencies and art directors will probably do the rounds of the graduation shows looking for new directions and new talent.

The better educational establishments will teach marketing and promotion as part of a business practice module. Many students will graduate with a set of business stationery, and possibly a website and marketing tools such as postcards, posters or even a published book based on their final major project.

Photographers wishing to enter the profession through other routes would do well to note the degree of directed preparation with which new graduates come to the marketplace. You, too, need to equip yourself with the tools for promotion in order to compete.

Though the newly graduating students may seem to have all the advantages, remember that there is a big change around the next corner for them, as everything in their lives suddenly has to become self-directed. There are no longer projects and modules to follow, on-hand advice from tutors or free access to expensive equipment. For this reason alone many graduates do not make a smooth transition into work.

'Target your efforts where you know there to be potential work.'

Active vs passive marketing

You can think of marketing as being either active or passive. A simple postcard could be used in either way. Leaving a pile of postcards at a public exhibition is passive marketing – it is random chance who picks one up, if they are spotted at all. However, a postcard can be used to actively target a potential client by being posted to an individual art director, or handed over during a meeting.

The success rate of passive marketing is very low indeed. A web portfolio is essentially passive unless the site is actively promoted; email and blogging are active marketing strategies. The key is to find the individuals who matter to you in the wider population, so emailing all ad directors with a general appeal will probably have no effect whatsoever, and may even be counter effective.

Using email in a targeted way to make a specific approach to a select few individuals having researched their companies and requirements – also their names – will produce far greater returns.

Cold calling is the name given to phoning, emailing or knocking on doors offering your services. It can be a most disheartening, time-wasting and unproductive experience. It is far better to target your efforts where you know there to be potential work. Stepping up from an assisting photographer to photographer is the most likely way to get work, but be aware that some photographers may see your attempts to talk to and impress their clients as poaching. Many people use their college work experience and go back to full- or part-time employment there, or begin to work with clients met through a job.

Remember: be contactable. Have, keep and use a professional-sounding email address. If you change your cell phone number, let people know. Respond to every enquiry, even if your answer this time is 'no'.

Representation and agents

It is very unlikely that a newcomer to the profession will initially need the services of an agency or representative. These are individuals or organisations that find work for you. They will negotiate with clients on your behalf, for a fee, of course. The fee is usually taken as a percentage commission rather than at a flat rate.

Some agencies are effectively one-person shows. Others are larger representative agencies handling a range of clients that may include people in the wider arts and entertainment industries. The upside of the bigger agencies is that they have considerable influence and reputation; the downside is they may have a quick turnover of agents and offer a less personal relationship than a smaller agency. Artist representatives may also represent models and top food or fashion stylists.

The agent's role

A good agent will not only promote you to potential clients, but will negotiate on your behalf. This can be important as it disconnects money discussions from creative work. Put simply, this lets you, the photographer, enjoy better relationships with the creative team as you do not always have to nag editors and art directors about late payments and cloud creative meetings with demands for rate increases. A good agent will also have far wider experience of the industry with a much bigger contact book and wider knowledge than you; they will also know of any changes in direction at the ad agencies or changes in staff on magazines.

Agents will also give good feedback on your work and may suggest entirely new routes and opportunities for your photography. They will also know the companies that are bad payers and will negotiate strongly on your behalf to get better licensing deals for overseas markets. Of course, an agent will need to justify the commission fees you will be paying and you need to be certain that you are getting the full range of services you expect from your agent, and that you are not paying for services you do not require. The best management agencies will also showcase your work on the web and their sites are often the first port of call for any ad director looking for photographers or a specific 'look' for an advertising campaign. Some agencies will go as far as location scouting and production organisation, or run picture libraries to promote and generate business from their represented photographers' existing images.

You need to consider employing the services of an agent once you have established a reputation and want to take your career to the next level. You should look on your relationship with an agent as something for the long term around which you can build your career confidently.

**Photographer's website
Simon Clay**

Your website is your shop
window – showcase your
best work. Keep it simple,
keep it fresh.

Professional bodies

Professional photography can be a very independent existence. Freelance photographers may feel isolated and even in competition with other photographers. It is also difficult to feel that your views are being represented in negotiations with big stock libraries or ad agencies. Putting you in a better position to negotiate and to be represented is one of the main reasons photographers join unions or professional bodies. Some are incorporated exclusively with this in mind. Founded in 1944, the American Society of Media Photographers (ASMP) describes itself as 'the leading trade association for photographers who photograph primarily for publication'. Its concerns are 'rights protection, promotion standards, ethics, community and camaraderie', which covers all the benefits a photographer can look for in a professional body.

Social photography

Other organisations are more like trade associations and stress accreditation, training and marketing – this type of organisation is very active in the field of social photography. Membership of organisations such as the British Institute of Professional Photography (BIPP), Society of Wedding and Portrait Photographers, the British Professional Photographers Associates (SWPP & BPPA), the Master Photographers Association (MPA) or the Professional Photographers of America (PPA) is aimed at full-time professional wedding, portrait and commercial photographers. Panels assess the standard of work before membership. The BIPP, for instance, describes itself as a qualifying body and like other similarly constituted bodies, offers three levels of qualified membership: Licentiateship (LBIPP), Associateship (ABIPP) and Fellowship (FBIPP). Assessments are closely controlled and recognised worldwide as a mark of professional development. Similar bodies exist around the world.

Professional bodies
(from left to right):
Professional Photographers of Canada, British Institute of Professional Photography, Australian Commercial Media Photographers, The Association of Photographers, Professional Photographers of America, National Press Photographers Association and The Photographic Society of Singapore

Becoming a member of one of the national bodies representing professionals in photography offers several advantages.

News media

National and international organisations also exist, which look after the interests of photographers working within the news media, such as the National Union of Journalists (NUJ) in the UK and Ireland, the International Federation of Journalists (IFJ) and the American National Press Photographers Association (NPPA). Some of the organisations issue nationally and internationally recognised press cards. Check with fellow freelancers regarding the specific acceptability of any 'press card' on offer – any trade body could charge to produce what might be little more than a piece of cardboard with your name and picture on it.

While many professional bodies have a long history (some going back almost to the birth of professional photography itself), one active organisation grew more recently out of email chat and information exchange between editorial photographers – Editorial Photographers UK (EPUK). With a very different model from other bodies, membership is free but restricted to full-time professionals who also run the website and provide the online resources. One of the most active and highly regarded associations is the AOP (Association of Photographers), which specialises in representing the interests of fashion, advertising and editorial photographers. Its strengths lie in its links with the education sector, its outstanding book on rights, ethics and business practice for budding professionals – *Beyond the Lens* – and its growing global reach.

Professionalism

The brief

Brief (n.) an outline, summary or set of instructions concerning a job or task

Workflow

Advertising production

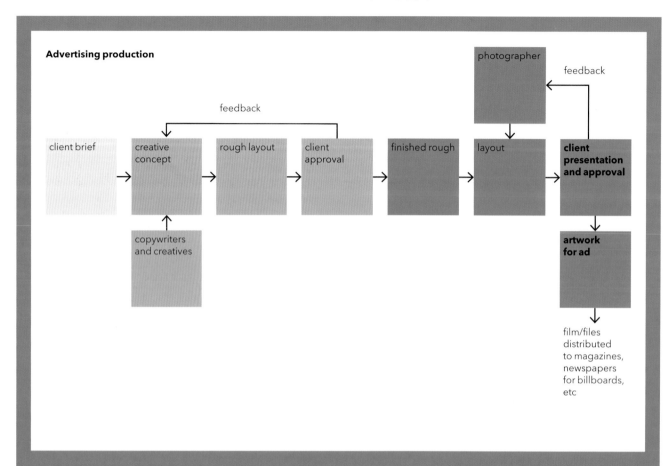

Advertising production

The brief is key to the production of both the final image and finished job – in this example, an advertisement. This shows a closed brief with the photographer working from a layout. In an open brief, the photographer would be involved at the creative concept stage. Feedback finetunes the brief.

Briefs can be formal or informal. They may be written down or they may exist simply as a shared understanding between the client and photographer. It is important that everyone speaks the same language when agreeing the brief, and that limits are set on creative approaches and on time and money. What every brief contains is a specification for the photographic job - some will be very specific, some loose. The brief will set out the mood or style for the photography and the final use of the images, whether they will appear on a website, be published in an annual company report or used on an advertising billboard. The brief is not a legal contract setting out the payment terms and deadlines; it is more concerned with the creative aspects of the job. There will most likely be a separate brief and contract for each job.

The photographer may get the brief from the clients themselves. An art or creative director responsible for commissioning photography will discuss the proposed job with the photographer and an agreed approach worked out. A brief may alternatively come from an advertising agency retained by the client. The photographer may then take direction from the account handler or creatives working for that agency. Briefs may be 'closed' or 'open ended'. A closed brief will specify precisely the look, composition and use of the final image. It may, for example, be necessary for the photographer to work around areas where text will appear in a final layout when creating the image. In all probability, a closed brief will mean the photographer working from a detailed visual or from a page layout.

An open-ended brief will consist more of a client's wish list and ideas about approaches. The photographer will need to know how the final image(s) will be used as this will influence the treatment - what is good for a press release is not necessarily good for an advertisement. It is very important for both parties to agree how much money and time will be spent on the project. Clear budgets and deadlines need to be approved beforehand. It may be possible to renegotiate the brief once work is underway. A client may even agree to extra studio time to create a particularly complex but compelling image - however, they may not.

In the fields of advertising, commercial and editorial photography, it is the clients who set the brief. In contrast, there are photographers offering highly specialist services (ground-based aerial photography using radio-controlled cameras on telescopic rigs, for example), who may impose a very tight brief on their clients, turning the usual relationship around completely. It may be important for an architectural photographer, for instance, to get the client to specify exactly what they want in the image. A written agreement in the form of a commissioning document produced by the photographer will prevent misunderstandings later and may even include getting the client to specify the time of day and viewpoint for the photographs.

The client

The client is always right – what they say goes. That may be the bottom line of the relationship between photographer and client. However, the best clients realise that they are not specialists in the field of photography, and may not be fully aware of what is cutting edge in either style or technique. Wise clients will rely on their creative team and set broad boundaries rather than try to limit their inventiveness.

However easy mobile phone and emails make communications, it is not advisable to start any major project for a new client without a face-to-face meeting. A lot will depend on how you get on as people and individuals; having empathy with each other can more easily accommodate creative differences. The language of emails is often open to factual misunderstanding and emotional misinterpretation – phone is better, face-to-face is best.

Client relationship

With a number of successful jobs achieved, a sense of trust will develop between the client and the photographer. It is, however, important that this trust is not misused. There are unbreakable rules concerning branding and each client will have their own set of conventions. These may not even be formally recorded and it is up to you to predict and discuss with the client. If you are lucky, there will be a style guide that lays out the 'dos and don'ts'. Company colours and the use of logos, visual jokes and humour based on slogans or company names are all no-go areas for the photographer who would be better off applying their creativity elsewhere.

As explained, you may not be dealing directly with the client, but with an advertising or public relations agency representing them. You then have to rely solely on their interpretation of the client's wishes. It may even be that the driving force behind a project is not exactly creative excellence. Controversial creative director Oliviero Toscani (see pages 144–145) summarised where the power lies in this relationship perfectly: 'Agencies get huge budgets, but the money is wasted because the strategies are decided upon by managers, economists, accountants, and focus groups – not the artists'.

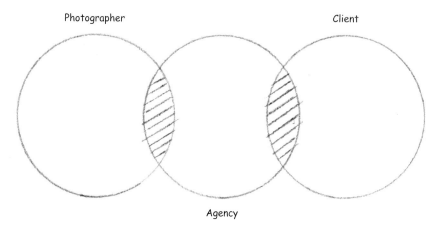

Photographer

Client

Agency

Photographer and client relationship 1

Sometimes the photographer and client do not meet and their relationship is negotiated by the agency.

It is rare that the photographer gets what they want into print or before the public. Accepting that the client is paymaster and that you are there to produce what they want and need is part of the professionalism you must bring to the job. If a photographer 'kicks off' about the creative approach, more often than not, they will be replaced rather than listened to. If you want to change minds, it has to be done by negotiation and persuasion.

Working for a client effectively means that you are spending someone else's money. You will be expected to both understand budgetary constraints and bring a job in within agreed budgets – and to negotiate if there are expected budget overruns. And if I did not mention it before: the client is always right.

Photographer Client

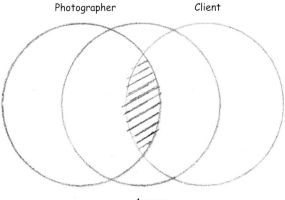

Agency

Photographer and client relationship 2

Sometimes the photographer deals directly with the client, but the relationship is managed by the agency.

A common language

If you cannot communicate your ideas as a photographer you will not easily get work, however good you are. Finding a common language is the key to putting over a convincing argument for your visual approach. It will help you feel confident that you have the acceptance of the client and your fellow creative team members.

A fashion or product designer can present a trend board to the client. This board will be covered with colours, textures, fabrics, plastics, pictures ripped from magazines and other materials – all going together to produce a strong visual context and identity. Photographers who try to use similar ideas with clients have to rely on existing imagery to show what their proposal will look like – it is then very difficult to dislodge an image once a client has seen it.

Be careful not to get locked into other people's 'look'. Clients may pick up on colours when you wanted to show them mood, while the face of a particular model may put them off a treatment. Better that you describe your own ideas. You could invest your time and effort in presenting test shots or using thumbnail sketches.

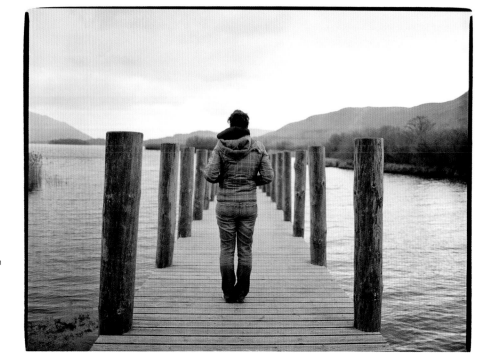

Rosa, Keswick
Andrew Robert Tyrell

Location scouting and careful technical planning are evident in this single image from a student's body of work, which documents the individual's reaction to landscape.

Pitching and presenting

It is certain you will have to present your own visual ideas clearly to others as part of your photography education and later professional practice. In college, you will have to describe your work, methods and motivations in a 'crit' or tutorial, answering questions about the work's style and content from your tutors and peers.

As a working photographer, you will need to find a language to describe your proposals and imagery that is immediately accessible to non-photographers and business people. It is best to assume that your audience has no prior knowledge of artistic movements and cultural phenomenon. Create a presentation that is self contained; explain every reference and influence for an intelligent listener, in an unpatronising way. Assess your audience carefully and make the language of the presentation appropriate. Presenting your ideas to a group of fellow creatives is very different and requires a different choice of language from presenting the same material to a board of directors.

It is best to be able to talk without notes, fluidly and convincingly, in a language appropriate for your audience. That probably means you will have to prepare the ground carefully. Write lots of notes, supporting arguments and ideas that you need to commit to memory. Look carefully at the vocabulary and language used. If you can, use visuals to convey your ideas – draw pictures for your client as part of the presentation.

Keep presentations short. Practice them until you are word perfect and the technology fault free. Use your own computer and projector if you can to avoid software and hardware incompatibilities delaying or spoiling the show. Finish on a high point with the strongest material. Treat it like a sales pitch and close the sale quickly and convincingly.

Thumbnail sketch
Andrew Robert Tyrell

Being able to show others your proposed work in a thumbnail sketch is something you develop at college, but which will support your professional practice.

◄ A common language
How far can your creativity go?
► Required outputs

How far can your creativity go?

It is all too easy – particularly when working in a good creative team – to become over ambitious or to exaggerate an idea. Creative teams often wish to sail close to legal boundaries and to those of good taste. To court controversy and notoriety is possibly better for the photographer and creative team than it is for the client.

Things can go quickly wrong if the tone of a campaign or image is misjudged. Public image is all important to the client who may drop a creative team or agency quicker than you can blink in the face of bad publicity. You need to go back to the client again and again for confirmation and feedback if you intend to deal in the controversial. Clients do not enjoy having controversy sprung on them.

Oliviero Toscani

Oliviero Toscani worked as a photographer and creative director between 1982 and 2000. His 'We, on Death Row' campaign was his last for Benetton. The campaign was too controversial even for Benetton – the ads began to generate negative publicity and the company began to lose sales in America. The United Colors campaign was always intended to be challenging and shocking – the images are meant to grab you and make you feel uncomfortable. They are very simply conceived, but they are explosive visual images that look unflinchingly at issues of race, death and gender.

Limits and boundaries

There is an important trust placed on the photographer by the client to respect their 'brand values'. Boundaries will differ from client to client – some will want to explore the 'edgy' and have their visual imagery close to the borders of the acceptable; others will want to keep clear of any controversy.

Photographers have to respect where these limits lie for each client. To see the boundaries clearly is sometimes difficult, especially when you are dealing with an agency or account handler who has to interpret the client's wishes and standards on their behalf. This is a subjective judgement call and relies on good communication between all the parties and personal sensitivity on the part of the photographer. There may also be legal aspects that need to be considered – these are the objective limits imposed by local and national laws concerning issues such as decency and obscenity.

Controversy

Sometimes the client and creative team together misjudge the public mood. An advertisement for Yves Saint Laurent Opium perfume, featuring the naked model Sophie Dahl, caused widespread controversy, becoming one of the most complained-about advertisements in 2000. It is a mark of the power of controversy that the photographic imagery was parodied a year later by Scottish Courage, the then brewers of Newcastle Brown Ale. Re-launching the bottled beer as just Newcastle Brown, their whole campaign recreated iconic and controversial photographic images. This included some of the raunchier Calvin Klein ads and Christine Keeler's infamous chair pose.

The United Colors of Benetton institutional campaigns: Black woman breastfeeding white baby (top) and Horses (bottom) OlivieroToscani

Toscani's is perhaps the most consistent set of powerful conceptual still life and portrait images produced in a commercial context. These campaign images demand the attention and careful scrutiny of anyone who wants to know how creative imagery works within the publicity and advertising machines.

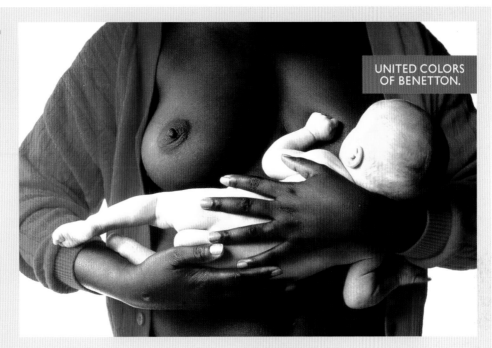

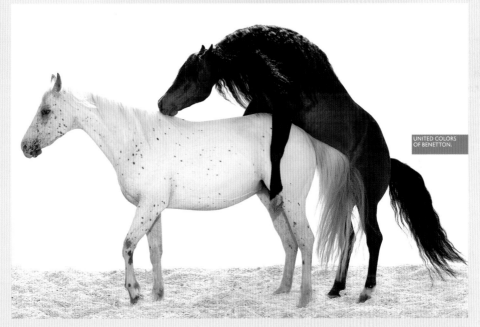

◀ How far can your creativity go?
Required outputs
▶ Timing and deadlines

Required outputs

Providing the correct image size and format would seem the easiest thing in the world to get right, but it is one of the most common mistakes made by freelance photographers looking to contribute to magazines. Each job you do will have different required outputs depending on the media in which you are working. If you wish to work for some of these publications, you might have to change your working practice.

The desktop printing (DTP) revolution of the early 1980s brought about a rapid loss of specialised jobs in the print and print production industries. At one time your images on film would have been handed to an individual who specialised in scanning and then passed on for colour separation by a skilled plate maker. Nowadays the photographer is expected to have many of these skills under their belt. They may be asked to deliver print-ready images that have been sized and supplied as CMYK separated files for printing.

Print requirements

Images for print are usually supplied at a 300ppi resolution when sized for printing (if you supply an image at 300ppi, but which is half the size (linear) of the client's use it will be effectively a 150ppi resolution image at print size). The colour space from your camera or the even wide space ProPhoto is not appropriate for print output; the client may specify that you supply images with an appropriate colour space for their workflow.

You may also be required to produce print-ready separated images in CMYK format and will need full details of the print profile you will use to achieve this. Soft-proofing the results on screen will immediately show any issues with out-of-gamut colours, which cannot be handled in print. This issue is very common where one image is to be used across a wide range of media – from high-quality magazines printed on glossy paper to cheaply produced newsprint. You may need to consider producing alternative versions of your image for different print media to get the best out of the available resolution and printable colours. It is more than likely that you will need to produce a high-quality, high-resolution master image and generate media-appropriate versions for each subsequent use (for full information on workflow see Chapter 6). File naming is very important and there should be an agreed convention between photographer and client.

**Magazines
Yanlai Huang**

Photographers familiar with editing RGB images may be required to produce CMYK colour separations for magazine and book use.

Digital requirements

Post-production aspects such as colour gamut and sharpening will be quite different even when dealing with the same image. Nowadays, it is up to the photographer to be aware of the different file types, colour management issues (profiling and colour spaces), and issues such as RGB versus CMYK. Many high-end photographers employ digital assistants who take this technical burden away from the photographer, who can then concentrate on the creative aspects.

Of course, you will need to be earning enough to afford an assistant. In fact, if your own interests lie towards the technical aspects of photography, being employed initially as a digital assistant with the right photographer could get you experience working with tethered high-end digital cameras in the studio, as well as post-production work on computer.

Web images are usually supplied with a 72ppi resolution, in sRGB colour space and in JPEG or PNG format; it is important to see that limitations in the reproduction of colour on the web do not unduly change the appearance of a distinctive product colour.

**Rambert Dance Company's
website homepage
Hugh Glendenning (images)**

Images for use in websites may require post-production treatment for size, resolution and colour space.

◀ How far can your creativity go?
Required outputs
▶ Timing and deadlines

Requirements for commissions

With commissioned work, the outputs will be clearly agreed between the photographer and other members of the creative team, usually a designer. You may be given a wide brief but may have to work around incorporating blocks of type in your image (magazine covers) or be careful over the use of certain colours to avoid clashes with product or company colours to be overprinted on the image. You may even have to shoot or crop to a specific aspect ratio that you are not used to.

You will also know exactly how and where your images will be used in commissioned work. You may even need to hire specialist cameras to achieve higher quality results if the advertising material you are producing is to be used on billboards, for example. If your work is speculative and submitted to a picture editor of a busy magazine, you know they are going to choose the images that require the least effort to get them into print.

It should be your aim to make any picture or art editor's job easy to choose your work by supplying images in an appropriate format. This may mean an email or phone call to the picture desk to ask about submission guidelines – you are not being any less of a professional by checking things out beforehand.

**New Emporio Armani
advertising campaign
Luca Ghidoni/Getty Images**

Giant billboard presentation promotes not only the celebrities and products, but your work as well.

Timing and deadlines

Magazine and book production are done on expensive printing machinery that can only be operated cost effectively if the machines are constantly kept busy with jobs. Each issue of a magazine or print run of a book will be scheduled well in advance to be produced in a certain time slot in the print works. There is almost no opportunity to delay printing to wait for editorial or advertising material, and printers' deadlines are absolute. As part of the production chain, the photographer must respect and adhere to any production deadline they are given. Technically, you are at liberty to delay and break a deadline, but the simple truth is you will not be asked to work for that publisher again; you may even gain a reputation as being too risky to employ – however good your photography.

There are of course other minor deadlines within the overall project. This is not, however, an invitation to miss deadlines and avoid meetings. As part of a creative team, you need to do what you say you will do and when you say you will do it. For the majority of jobs, reliability is as important as creativity.

Your fees and your time

The old adage 'time is money' is absolutely true in creative photography. Any time spent on a project has to be covered by the final fee. There is little or no point negotiating ten per cent over your normal rate for a job that is going to take you twice as long as normal. As the topic of money has come up, it is probably the best place to answer that most common question: how much do I charge?

Work out how many days a year you can work. You cannot work seven days a week and probably need two days for planning and post-production, which leaves three days to earn. Allowing for holidays, illness and times you will be simply unavailable for personal reasons, you can probably expect to work 46 weeks in a year – 138 days in which to earn your yearly expected salary, plus cover your overheads. These are the additional costs of replacing equipment, rental of office space or studios not directly billable to the client. Work it out now. You will never earn that day rate.

Corian calendar
Niels Kjeldsen (designer)
and Leo Torri (photographer)

Being able to deliver work to short and immovable deadlines is part of what it takes to be a professional.

So how do you survive? The simple answer is by carefully guarding your rights, and selling extra rights and syndication rights when you can. This means keeping your rights in your work and selling it more than once; selling images for stock and never dropping below your minimum rate for smaller jobs.

Time management is vital for each individual job and your ongoing professional career. That means each job needs to be planned with appropriate and sufficient time to prepare and create the final image. In the longer term, the photographer's working pattern has to be planned so that unexpected jobs for existing clients can be accommodated. This would also allow time for developmental and personal work. Smaller jobs can be slotted into a regular pattern of larger jobs.

◀ Timing and deadlines
Legal issues
▶ Passing off and plagiarism

Legal issues

The law enters into the relationship between the photographer and client. A contract is a legally binding agreement, which means it can be enforced in a court of law. There are certain features a contract must have which include an offer, an acceptance (recognising the agreement of a common purpose) and some form of reward or payment.

Contracts do not have to be written down but it is in everyone's best interest that this is done. A verbal agreement is hard to prove one way or another without witnesses. Photographers are encouraged to get as much as possible down in writing and to have a legally binding contract for each job. Where this does not happen, it is in your best interest to confirm all aspects of the job in writing to the commissioning party. The contract is your protection – without it your work could be disputed or payment not forthcoming.

The offer and agreement of a job

After an initial discussion, the client will brief the photographer, who will then supply an estimate.

The client will then raise and send an order, which is an acceptance of the photographer's estimate. This will contain agreed terms and conditions, including full details of copyright assignment, payment terms, ownership of materials, agreed usage and other negotiated rights.

Particularly important is the usage as this may help a photographer recover payments from an end-user if the agency that commissioned the work becomes bankrupt before paying. The photographer may have to negotiate further contracts with people he or she subcontracts such as stylists, models and set builders.

Copyright

Just what is copyright? It is a right in law to publish (or restrict publication) of an image, and assign rights to others authorised to publish the image – and to be paid by them. In truth, it is a very complex legal issue that changes as new legislation is brought in and old laws tested in the courts.

You do not have to do anything to record or create copyright – the rights are yours as the creator the moment the image comes into existence (this is certainly the case in the UK though American law differs in its treatment of registered and unregistered images). How long copyright lasts depends on where copyright is held.

Copyright can be reassigned, sold and in some instances revived by heirs or beneficiaries. As copyright holder, a photographer can sell licenses to reproduce their work in any media and territory, for any time period. Assigning copyright means others control and may gain financially from your work. It is the difference between hiring and selling. Photographic trade bodies recommend photographers look on copyright assignment as a last resort.

Copyright law is there to set a balance between the rights of the creator and the needs of those who want to use an image (or have access to it in the case of research). This book can do little more than make you aware of some of the many complex issues surrounding copyright and suggest you always take professional, up-to-date, local advice on any issues concerning photographic copyright.

'Any time spent on a project has to be covered by the final fee.'

◀ Legal issues
Passing off and plagiarism
▶ Model and property releases

Passing off and plagiarism

Plagiarism is the technical term for taking someone else's ideas and work, and passing them off. Passing off means pretending the ideas are your own - the key is in the 'knowing deception' of others. Though there may be photographers who intentionally copy others' work, this is more often a trap that photographers fall into by accident. This has already been mentioned previously when a client is presented with images taken by others to support your proposed creative approach. The client then becomes so attached to the specifics of your example that you end up having to recreate other people's work to satisfy your client.

The easiest way to prevent this from happening is to not present existing photography at a creative meeting. Do not use other photographers' work as suggestive of your own approach - you will only end up copying or modifying their work at best. Always believe you can do better.

Fine balance

As part of college and university photography courses, students are often required to recreate a well-known photograph by a famous photographer. Without clear guidance from tutors on the full implications of such exercises, this practice can later lead to imitative commercial work that at best is creatively disappointing and at worst is genuine plagiarism.

The reason you are asked to do these exercises is to initially sharpen your skills of observation and to teach you how to manipulate lenses and lighting with a known goal in mind. You are then expected to use this knowledge as a springboard for creative exploration and individual expression. Think now of doing this not in the context of a college course, but commercially. If you simply stopped after the first part of this brief, you would be passing off; completing the brief you are being creative within recognisable and achievable limits. The real aim is to be able to find your own source material for creative exploration and to not rely on pre-existing imagery.

The skill in looking at photographic source material is to dig deep and go back to the idea of 'intent' (see pages 34-35). Look for the photographer's motivations and be inspired by those. By appropriating the superficial look and style of the work you are not only deceiving your client - you are fooling yourself.

Seen this somewhere before?

Yes, it is a 'recreation' of Irving Penn's conceptual still life 'Food of Italy'. Passing off is using your copy of another photographer's image and claiming the idea as your own. You could not use this image, for instance, as a commissioned illustration for a feature on Italian food. So why copy? You will learn how a great photographer uses light and that this arrangement was probably held together with matchsticks!

Model and property releases

You may be aware that you need someone's permission to publish his or her likeness. What you may not be aware of is that this can extend to images of property as well as people. The 'rights to your own image' and how it can be used differ so widely from country to country – you need to seek out and comply with local laws and customs. Privacy rights in France are much stronger than in the UK and America, for example. This is less of an issue to photographers who employ models rather than those who may photograph members of the public, such as a photojournalist.

**Untitled
Raymond Ellstad**

It is best to have a signed model release form for any imagery that includes a person – whether they are a professional model or not.

Model release forms

Model release forms set out in a basic contract the agreement between model and photographer over the ways in which images will be used, and the consideration for their use. Consideration could mean money or copies of prints or a free meal – it needs to be explicitly stated in the form. You can see from the example on the next spread how the details can be filled in. It is usual for both photographer and model to keep signed copies of the model release form, which should also be witnessed. Child models need the signature and agreement of a parent or legal guardian.

If you are booking a professional model from an agency, it is more likely that the model release terms will be included in the contract between you and the agency. You then become liable to pay extra if your client uses the images outside the agreed use – if they decide to run an additional poster campaign from images originally intended for a magazine advertisement, for instance.

Permission forms

It is becoming increasingly advisable for photographers to get written permission for publication – even from members of the public who appear in your images. There are some exceptions in the UK, which includes people who have intentionally put themselves in the public eye – those dressed for and taking part in carnival parades, for instance. Many photographers now get around this perceived restriction by never including a recognisable face in their images – they use long shutter speeds to blur passers-by or more simply, photograph people from behind (not always legally defensible).

If you do take a picture of a member of the public, you must not use it in an advertisement without prior permission. You certainly must not hold them up to ridicule or suggest they are involved in some form of crime, unless you wish to be sued for defamation. Stock libraries recommend that you need a model release form if you include any part of the body from which a person could recognise themselves (not just be recognised by others).

This has made the selling of stock photography particularly difficult for some forms of imagery as the stock library will request and require legally binding model and property release forms for all stock images. Some libraries will accept property images without release, but this will be noted in the library database and potential customers will often simply avoid images that are not fully covered in this way.

◄ Passing off and plagiarism
Model and property releases
► Teamwork

**Sample model release form
Contract Store**

Have some blank forms of your own printed and ready for use; keep copies of them with your camera equipment.

Model Release Form

Model Name and contact details:...

...

Photographer Name and contact details:...

...

Date(s) of Shoot...

Location: ...

Photographs for use in[1]:

 Website Brochures/promotional literature Magazines & newspapers

 Advertising Full library use

 Other...

Model may be identified by name: Yes/No[2]

For the consideration indicated below, I agree that the Photographer and any person, firm or company acting on their behalf or with their consent is entitled to use any images derived from photographs taken of me on the date(s) mentioned above for the purposes described above [and for any other purpose][3] and in any media. I also agree that the images may be combined with other images, text and graphics, and may be subject to digital enhancement.

I accept that I will not be entitled to any further payment in respect of the sale or commercial use of the photographs and that I have no copyright or other intellectual property rights in any of them.

I undertake not to institute proceedings, claims or demands against the Photographer or any third party who lawfully acquires the photographs or images in respect of any usage of the above mentioned photographs

Agreed consideration/fee payable to Model:

I have read this model release form carefully and fully understand its meaning and implications.

Signed: ... (Model) .. (Witness)

Date: ..

If the Model is under 18 years of age, a parent or legal guardian must also sign:

Parent/Guardian..

Date:...

[1] Circle the relevant items
[2] Delete whichever is not appropriate
[3] Either delete the wording or remove the square brackets

© ContractStore Z164

EXPLANATORY NOTES

This Model Release Form is straightforward and is designed to ensure that the model confirms that he/she has given consent to the photographer to make full use of the photographs. The Model Release is a contract between the photographer and the model to agree how the images may be used. Without a signed release a photographer may be unable to sell an image of a person, even if the subject was not a professional model and provided verbal consent.

The form has various details to be completed, in particular the name and contact details of the model and the photographer. In addition the form identifies the date on which the photographs are taken and the nature and purposes for which the photos are being taken. The usage can either be restricted to the purposes identified in the form or usage can be unrestricted.

The text makes it clear that not only the photographer but any third party who has the photographer's consent can use the photographs and that the images may be digitally enhanced or used in conjunction with other images and text.

The form sets out the 'consideration' due to the model – this will often be a payment but it could be a nominal amount or something other than cash – e.g. a set of the photographs.

If the model is under 18 then a parent or guardian needs to complete it on their behalf.

Z164

Property release forms

A property release is written permission to photograph and use images of things owned by another person. Usually applied to houses, a property release would also be needed when photographing a prize-winning pet or a classic car as both are the property of their respective owners and you need the owner's permission. This also covers brand logos, recognisable product designs (an Apple iPod, for example), and any work of art or illustration. It is always best to attach an image of the property or model to the copy of the release form that you will file.

Taking photographs in a public place or even taking photographs of a private place from a public place is not against the law and requires no permission in some places. However, there are many instances where a photographer's actions will be restricted – certainly in the UK, if a photographer is likely to be a public nuisance by blocking a thoroughfare, or cause a breach of the peace then their photographic activity can be curtailed by the police. Security guards cannot demand you stop photographing in a public place, but you may have misunderstood what is public and what private. A shopping mall is not a public place, for instance, as the land is privately owned (as are more and more of our city streets).

Australian law, for example, enshrines the principle that the owners of a private space can control what activity takes place there – there is no formal requirement to state that photography is not permitted even when it is not. A private space in this context could include the shopping mall (as mentioned), but also cinemas and art galleries, even a sports arena. The rule is always to be aware of national and local law and to plan and ask for authorisation beforehand.

**Beach Shack,
Holden Beach, NC
Mystic Photography/
C Mastrovich**

A property release may not be required when photographing from a public place, but written permission can avoid later misunderstandings.

◀ Model and property releases
Teamwork
▶ Safe working practices

Teamwork

When you rely on your own skills and judgement to create an individual photographic 'look', you are clearly a strong-minded person. Working with others in a team can be a difficult skill for a photographer to learn. A group will discuss problems and form decisions based on dialogue. Larger groups may have formal meetings and break into smaller subgroups to solve specific problems, the outcomes of which are reported back to the main group. In a group discussion, statements will be made by individual group members, which will be received by the group itself; individuals in the group will agree, disagree or debate the point.

The mediator

Things are fairly sure-footed with technical discussions, though not always. When the discussion moves on to opinion, strong feelings will begin to be revealed. It is important that a mediator is appointed and accepted to chair the group. This does not have to be done formally, but any creative group needs to accept that one of its members should undertake this role.

The chair's role is to prevent dialogue descending into simple disagreement, to move the discussion forward towards decision taking, and to prevent the group fracturing into self-interested subgroups. It is not an easy role to play – it requires tact and a willingness to sometimes suspend your own point of view. You may sometimes need to be able to draw out ideas from reluctant group members, while keeping more opinionated members politely in check. The most important aspect of the chair's job is to pull the decision-making process together at the end of the meeting, and summarise the decisions and actions to be taken by the members of the group.

It is still best to circulate an agenda by text or email to give group members some time to think about the issues involved and to be ready to make a contribution when the meeting is called. The agenda has no need to be formal as long as it sets out the subject(s) that is going to be discussed, and who might be expected to make a contribution on a specific topic at the meeting.

'Working with others in a team can be a difficult skill for a photographer to learn.'

Identifying skills and roles

Once the job is underway you will be working with a different team. In the studio or on location, the photographer will need to rely on different sensitivities and personal skills. It usually becomes clear early on in your career whether you are destined to be working with just one or two people (an assistant and studio manager) or whether you will relish working within a larger group of stylists, models, digital assistants and possibly other photographic specialists.

It is common for regular but informal teams to come together for studio or location shoots – friends of the photographer, other 'resting' photographers may turn up as assistants. You may find that most of the people already know each other both from the job and socially. For a newcomer this can be unsettling, but you first need to see that you perform the tasks allotted to you and do your job to the best of your ability. That way you get invited back!

At work in the studio
Student photographers at
Blackpool and
The Fylde College

At college or university you will soon find out whether you enjoy working in the studio and how you like to work: alone or as part of a team.

Safe working practices

If you are employed as a photographer by a small company, the employer has a duty of care to ensure your health and safety at work. Employees must take reasonable care of their own safety and that of others. In a company, there should be formal risk assessments, and possibly training, to comply with the law. Things are a little different for freelance photographers. As a self-employed person, you would be expected to act in a way so as not to put others at risk and to not expose any person you contract to health and safety risks.

Assessment is the first part of risk management. The first part of risk assessment is to identify the hazards in the workplace. This could be either a studio or a location, and risk assessments should be done specifically for the place you intend to take location photographs.

Hazards and risk assessment

A hazard is any object or circumstance that has the potential for harm. In the studio, for instance, cables thrown across the floor would be considered a hazard and the nature of the risk would be tripping up over those cables. Once you have identified the hazard and the nature of the risk it poses, you need to identify and apply control measures. These are the steps taken to control the risk. To use our example of the studio cables, the control measures would be to coil the cables near the lamp bases; to reduce the amount of clutter; to tape cables down in heavily trafficked areas if necessary; and to give clear warnings to people using the studio.

If you have your own studio and/or offices, you need to consider risk assessments for fire and electrical safety; use of computer equipment (seating and screens), issues over lifting heavy weights and the control of substances hazardous to health (COSHH). Though digital photography has reduced some of the chemical risks, there are still important safety issues concerning powdered toners and adhesives used in printing and photography. A recognised electrician should test anything that is mains powered for electrical safety.

As a freelancer you need to look after yourself and this must include proper training in the use of studio or lighting equipment where it has been hired – you may need to get additional information on how things operate, so ask the advice and follow the instructions of the studio manager or representative of the hire company. Always follow 'good practice' and safe systems of working, which includes good housekeeping (keeping the studio or location clean and tidy), and keeping an eye open for new risks as circumstances change.

Insurance

A freelance photographer using models, stylists and assistants needs to have up-to-date employer and public liability insurance. He or she also needs to understand the limitations of the policy's cover. For instance, does it cover you if you take an overseas assignment? Public liability covers you against loss or damage to property, or injury or death of another person. You are covered against a member of the public suing after they trip over a cable on a location shoot, for instance.

Professional indemnity is recommended as this covers the photographer against claims of professional negligence, which could include the dishonesty of someone you employed or a breaking of copyright law – more common today are claims for defamation and slander.

Interior of photography studio iofoto

Photography studios come in all shapes and sizes. It is your responsibility to check out any hazards and to ensure a safe environment for yourself and others.

5

The brief

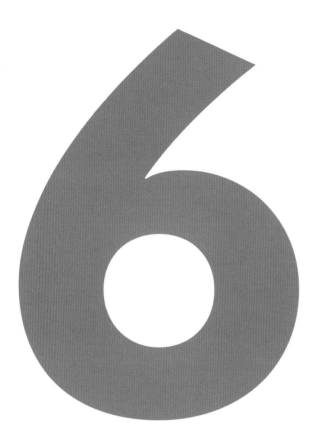

Workflow

Workflow (n.) the sequence of processes through which a piece of work passes from conception to completion

Digital workflow

Camera work takes up only part of the digital workflow with pre-planning and post-production being vital elements.

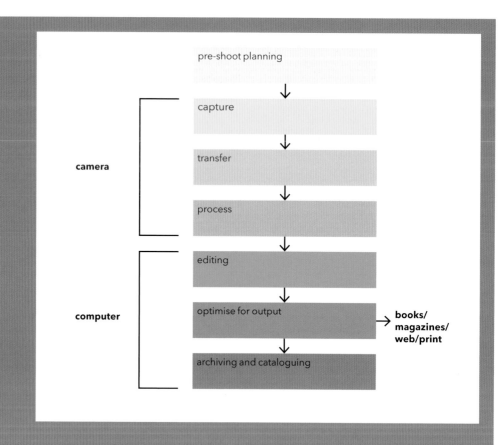

This chapter concentrates on the digital photographic workflow and not film workflow, which is very different. Workflow follows the processes in the creation and preparation for use of a digital image. The first process is the pre-shoot planning. This would include conceptual development of the types of imagery to be created, and consideration of the equipment needed to create and capture the proposed approach. With the right ideas finalised, the equipment chosen may need hiring, but will certainly need checking through before being used. Batteries will need to be tested and charged, memory cards sorted and formatted.

Capture is possibly the most straightforward part of the workflow, but it is where the photographer's technical knowledge and creativity comes together. The captured images then need to be transferred from the camera to computers for editing. This may take place out on location on to a laptop for onward transmission by mobile phone or broadband. Alternatively, the camera may transfer its images directly to a studio-based desktop computer in what is known as a 'tethered arrangement'.

Once on the computer, it becomes vital to protect all stages of the process by implementing a rigorous backup regime for the files, never deleting or wiping camera cards until copies have been made and verified. To be able to see the images shot by a digital camera, it becomes necessary to use viewing and cataloguing software. Once sorted and rated, the images will then need to be processed from the Raw format in which they were captured to become editable 'instances' of the Raw camera capture. Adjustments for exposure, colour balance and a myriad other image aspects can be applied non-destructively at this stage. Once the Raw file has been converted to an editable copy it may be necessary for picture content to be edited or altered, or a composite image created from a number of original captures. This is done using image-editing software with powerful layering and masking features such as Adobe Photoshop, which has become the industry standard.

Finally, the file will need to be output in possibly different sizes and forms for different media and for cataloguing purposes. Some computer applications such as Apple Aperture and Adobe Systems Photoshop Lightroom now incorporate large parts of the image workflow in one convenient application.

Photographic workflow

The independent photographer will develop their own workflow based on favourite products. These will be software packages that achieve the desired effects, but do so economically in terms of both time and money. Many independents use only part of a larger program, perhaps preferring to use the camera manufacturer's Raw file processor before using a third-party stand-alone product. The image is then passed on to image editing software such as Photoshop.

Printing may even be handled by a dedicated RIP (raster image processor). Although a single product like Photoshop could handle every phase of the workflow, it is increasingly common to find individual photographers mixing and matching features into complex and personalised workflows.

Workflow patterns

Large organisations, such as established photographic studios and magazines or newspapers, will have carefully structured and possibly rigid workflow patterns that the newcomer needs to learn and work within – whatever their own experiences working as an independent photographer. It is best to have an 'old-hand' take you through the specifics of such a workflow before attempting to process your own work – parts of the process may even be handled by digital professionals and no longer be in your hands. This loss of autonomy is something that many photographers find hard to handle but have to accept.

There are almost as many detailed workflows as there are photographers. Working a wedding two-handed or as part of a big editorial team covering a major sporting event, such as the Olympics or Superbowl, require very different workflow approaches from working as a natural history photographer shooting for stock.

Sample workflow for wedding photographers

- Synchronise camera time stamps.
- Coverage and capture specifics down to individual photographer.
- Back-up original camera files onto a secure computer hard drive.
- Create a catalogue of photographs sorted by capture date and time.
- Cull technically poor images.

- Batch rename and write metadata.
- Back up to archival quality DVDs – one set of disks per client.
- Catalogue, storage and set-up archive.
- Review and edit files; delete rejected images (this time based on subject content – poor facial expressions etc); edit down before presenting to client.

- Modify selected images with Photoshop.
- Present images to client: run a slide show from the catalogue of updated images using digital asset manager.
- Prepare selected images for output and printing.

Sample workflow for a wildlife photographer

This workflow is adopted by a photographer working independently to produce images for a picture library and is based on a hierarchy of computer operating system folders.

■ Raw File Library: all images, regardless of project, are brought into a 'File Library' on an external hard drive where they are subdivided into DVD-sized sub-folders and backed up to DVDs.

■ Processing: the Raw file library is catalogued and a selection made using cataloguing software for image processing in a stand-alone Raw processor (for example, Capture One).

■ Processed TIFFs: some files that require no editing are moved to a master folder, some are gathered for retouching.

■ Processed TIFFs to retouch: these are the files identified as needing spotting or some other Photoshop work from the previous stage.

■ Master TIFFs: files for clients/picture libraries – all catalogued and keyworded.

All files progress through this assembly line of folders. There is no hierarchy of folders to search through – the whole workflow is based on work done to the file.

Basic workflow: Pre-shoot

Workflow pre-shoot is just another name for planning. As in the old adage 'poor planning promotes poor performance', the smooth running and successful outcome of the photographic workflow depends on the quality of the planning. Clear goals, recognised outcomes and the ways to achieve them are part of the job planning. The photographic workflow planning focuses more on the specifics of the technical process. The major issues to be addressed are equipment calibration and the adoption of a colour management regime.

Colour management

Colour management is the process that attempts to match colour from camera input through display on a computer monitor to printed output, whether that is an inkjet proof or magazine page. This is the job of a suite of computer software – some of which may be part of the computer operating system (as in Apple's ColorSync) – or a combination of hardware and software, such as the innovative ColorMunki.

To accurately control colour throughout the workflow, colour management systems need a profile of each device (camera, screen, printer, scanner, etc). The data from each device can then be modified – based on information from the profile of its colour performance – and its colour adjusted. This is so that what you see through your camera is the same as what you see on the computer screen and what eventually gets printed.

'Clear goals, recognised outcomes and the ways to achieve them are part of the job planning.'

Calibration

Calibration is adjusting or re-adjusting a device or mechanism so it conforms to a known standard. Computer monitors are calibrated for their colour temperature white point, contrast (gamma) and black-and-white luminance. This process gives them a known and consistent performance from which you can make accurate judgements about colour balance.

Imagine if you attempted to rebalance the colour of a model's skin tone on a computer monitor that was too pink. You would adjust the colour to achieve a natural skin tone by adding a little green and blue. Everything would look fine on screen. When you printed the file, however, the results would be a blue-green colour cast on the skin tones as you had corrected for an error on the screen and not an actual colour cast in the image.

The output of the calibration process, which entails photographing or scanning a known colour target, is a data file describing the performance of the camera or scanner, known as a profile. These profiles accurately describe the colour performance of an input or output device or attributes of a colour space and are usually produced according to the standards of the International Color Consortium. They are therefore known as ICC profiles.

Given an ICC profile for a printer type and a specific paper, a software application such as Adobe Photoshop can show the colour qualities of the output without ever printing a page, using a process known as 'soft proofing'. Having a reliable and proven colour management system in place before any job is started is essential for the professional photographer.

Basic workflow: Capture

The capture phase of the workflow involves the actual picture taking, but there is a good deal of decision making required by the professional photographer before a shutter is actually clicked. These decisions will involve the colour space in which the files are to be captured, the size and type of file for the image and - based on this decision - there will be issues involving exposure and white balance to consider.

'Professional' cameras permit the use of the larger Adobe RGB (1998) colour space, as well as the more limited sRGB space adopted for ease of printing of consumer images. There are occasions when a professional might wish to change back to shooting in the sRGB colour space in order to avoid later conversion back to sRGB (for images used only on the web, for instance). The decision is part of the capture workflow checklist.

'Check the settings and operation of a camera before any significant work is undertaken.'

Types of 'capture'

The next major decision will be between Raw file capture and JPEG or TIFF capture. Raw files are bigger – and so fewer can be stored – and take longer to process on the camera. JPEGs offer faster capture and many more can be stored on a camera card. However, Raw capture offers non-destructive post processing with the possibility of sharpening, white balance and even exposure adjustment without the loss of picture quality.

Any changes done to JPEGs lower picture quality. Many news and sport photographers use JPEG because they need a wider choice of images and often shoot in fast image bursts – newspaper reproduction is not ultimately demanding of quality. Any other professional who knows there will be any post-production work would be advised to use Raw image capture.

It seems an obvious piece of advice to check that the camera works and works accurately, especially regarding the light meter and exposure. It is advice that is often overlooked. It is particularly important to check the settings and operation of a camera before any significant work is undertaken, especially if it is a pool camera from a newspaper or magazine, or on-hire. An exposure check is crucial and time should be taken to re-format all memory cards to be used in the digital camera, which will weed out defective cards.

White balance

White balance checks were once a vital part of the film photographer's workflow, and although with Raw capture white balance is less important to get right on the shoot than it once was, it does no harm to consider and attempt to accurately set white balance. Wedding photographers will commonly re-balance white at each new location to ensure best results – the precise colour of the wedding dress is important to the wedding party, and it should be to the photographer also!

One professional photographer working in crime scene photography once remarked that his job was, with digital cameras, more one of battery management than photography. The provision of enough battery power to cover the day's shooting – and more for safety – is vital. A digital camera with a flat battery is as much use for picture taking as a brick, while many film cameras can at least be mechanically operated.

Basic workflow: Transfer

The transfer phase of the digital workflow looks at how the images are taken from the camera on to the computer for subsequent processing, editing, cataloguing and storage. One important choice is whether to read the files directly from the camera or to remove the memory card and read the files from that. Reading the files directly from the camera guarantees that there are no connection problems with card readers (which is actually quite unlikely), but it has the disadvantage of running down the camera's batteries.

Memory cards and backing up

Many photographers prefer to remove the memory card from the camera and connect it directly to the computer through a card reader. This has the advantage of saving the camera batteries and permits the camera to be used with a second card while the first is being downloaded.

At big sporting events covered by a number of photographers for a big-name magazine or news organisation, it is possible to find a digital assistant acting as a runner between the photographers and a central production 'office'. The runner collects used camera cards and returns formatted cards to the photographers, allowing them to keep on shooting – with sports subjects and a modern high-resolution digital camera on high-speed continuous shooting, cards can very quickly be filled.

For the photographer working alone, the logical workflow is to have enough camera card capacity to continue shooting until you can return to base. Some photographers prefer large cards so they can avoid swapping cards and missing picture taking opportunities. Others who work with less demanding subjects may wish to consider a number of smaller cards – there is nothing worse than a large card going faulty and needing recovery – or worse still, being lost or damaged beyond recovery.

Logic dictates that your images are most vulnerable when they exist only on the camera card. A memory card must not be wiped until backups have been taken. The card should then be reformatted in the camera in which it will be used – not simply erased, but low-level formatted.

Wi-Fi

The rapid advances in Wi-Fi technology mean that many photographers will use a wireless connection to transfer their images from the camera to the computer, possibly for onward transmission to the picture desk. High-end camera manufacturers sell dedicated wireless transmitters. None of these have the ease of use the consumer enjoys with a simple Eye-Fi share card, which combines a Wi-Fi transmitter and image memory on the same tiny SD card. Though this has been pioneered in the consumer market, it will undoubtedly become the transfer method of preference for the professional photographer.

'Your images are most vulnerable when they exist only on the camera card.'

Basic workflow: Process

The processing stage of the digital workflow is a similar operation to film development – it is the technical realisation of the images from the shoot. Although direct JPEG capture has been discussed as a possible option for some photographers, the digital workflow presumes Raw capture. Processing is the stage that takes the Raw file and produces a suitable file for editing and optimisation for a particular media, be that print or display. The Raw file from the camera is not the same file used for editing or output. Processing creates an 'instance' of the Raw file, corrected and adjusted as regards exposure, white balance, colour cast correction and initial cropping.

What is a Raw file?

Raw files are simply the files from the camera sensor unprocessed by the camera. The advantage of Raw files is that a dedicated computer can produce better results from processor intensive tasks, such as demosaicing, sharpening or noise reduction, than can the camera's on-board computer. Raw files have 12- or 14-bit resolution and provide some degree of future proofing. Each manufacturer employs their own proprietary Raw file format and dedicated software to process and print from their Raw files.

However, the different formats are not readily compatible; a Raw file from one camera will unlikely be processed correctly in the software bundled with another camera, if processed at all. Adobe Systems – producer of Photoshop – has produced an open-standard for camera Raw files in their digital negative (DNG) format, which has been adopted by only a few manufacturers (see Archiving on pages 184–185).

There is a range of Raw processor software available. The major camera manufacturers, such as Nikon and Canon, produce Raw processors like Capture NX2 and Digital Photo Professional respectively – some are bundled with the professional cameras and some have to be bought separately.

Raw file processors

The latest generation of Raw file processors offers a wide range of modifications including spot removal, digital graduated filters and noise reduction. Some offer limited or selected editing to colour, and some feature cloning or healing. The settings that are chosen through the Raw processor are applied and what was a Raw file is now a TIFF (usually). It is this processed file that makes its way through the remainder of the workflow for possible content editing; not the original camera file. Processing can also be done on a batch basis and a house style or photographer's personal 'look' applied to a range of images at once through the use of development (processing) pre-sets.

'Raw files are simply the files from the camera sensor unprocessed by the camera.'

Basic workflow: Editing

The editing phase of the digital workflow is really a two-part process. One aspect includes the selection, choice and cropping of images – this may be done before or after processing, depending on workflow specifics, and is distinct from content editing. Some Raw processors offer the means to select and compare processed or pre-processed images, and users will make the first part of their editing selection in the Library module of a workflow product such as Adobe Photoshop Lightroom.

The second aspect – content editing – has to be done using image-editing software. This will include heavy retouching (some can be done in certain Raw processors, but not all) and any layering or composite imaging where parts of different images are brought together to make a final composite.

Cropping, picture straightening and rotation may all be part of the general editing stage, though it is technically better to incorporate this during processing. This is to minimise image degradation from progressive image editing. Far better to get as much as possible done during Raw file processing.

Who does the editing?

More often than not the photographer is not making the final selection. They will not be responsible for the selection of the final image that will appear in the published advertisement, for example. It may be that the editing is done quickly in the studio with the art director and photographer working from a computer monitor or using a laptop with images from the location shoot. This may be done using the View or Library module of the Raw file processor or using a dedicated asset manager that can prepare a catalogue of Raw files for comparison, selection and marking.

It will then be left to the photographer or digital assistant to work up final production files from a smaller selection of images. It may be that a 'look' needs to be applied to a batch of images, or the batch colour-matched, before a selection is made. A small handful of images will then be presented to the client and a final choice made. Word may come back down the line that some content editing is required to change a prop or to alter a garment colour. The file will then be progressed to the next stage of content editing and passed back to the client for final approval.

Editing software and techniques

Content editing is the domain of Adobe Photoshop (and similarly capable products such as Corel's PaintShop Pro). These products work with image layers and can be used to change the content of an image dramatically. A classic example is substituting one sky for another or a studio-photographed model placed against a background from an exotic location.

Layering not only permits powerful image adjustment, but also the creation of complex blended composite images made up from multiple image sources. Although this work is usually in the hands of digital specialists, you need to hold on to your photographic appreciation for textures, lighting, scale and perspective if you attempt to create a composite image yourself. Often, these images are littered with clues as to their origins, such as unbelievable shadows or poor cut-outs. Good masking and accurate cut-outs are time consuming and many of these tasks are handled by specialist pieces of software working within Photoshop. For the photographer considering image workflow, it may be worthwhile paying to have such work done on images by a specialist. Skin and portrait retouching is one such specialism.

Aesthetics vs ethics

A question of ethics is raised due to the power of these programs to change images yet keep them looking believable. There are three major users of image-editing software: commercial photographers, social photographers and journalists. Each field has its own acceptable-use policy, which may simply be accepted practice or adherence to a published set of guidelines. The easiest to discuss is photojournalism.

Images can be technically improved and enhanced (if necessary) in order to better see content, to overcome technical limitations (such as lens distortions), or photographic defects (such as sensor dust spots). The content of news images should never be altered.

There is a grey area with imagery for features and for magazines. For instance, celebrities may be moved closer together in images, ostensibly to fit the page layout. This may be acceptable in some contexts, but the practice rapidly moves into indefensible territory. Retouching images in the field of social photography is an accepted practice – a recommended 'rule of thumb' is to remove temporary blemishes, but leave the freckles and laughter lines. These rules change if the intention is to create a makeover image.

Image reality almost disappeared in some sectors of the advertising industry – female faces and body form are regularly distorted. The question here is not the industry standards, but the wider social implications. The answers are not for this book, but the individual photographer should consider questions of design responsibility, image integrity and honesty.

Basic workflow: Optimisation for output

Images destined for the Web need to be treated in quite a different way (regarding resolution, colour and sharpness) than images headed for the print media or for fine-art printing. When preparing files for output, you must be prepared to ask questions and not make assumptions about subsequent use. For example, if you are preparing an image for a book jacket illustration, you need to know if you are expected to deliver the job as an RGB file or handle the colour separation yourself to produce the requisite four-channel CMYK file for four-colour printing.

If you are required to make the separations what profile are you expected to use? You will also need to know details or 'mechanicals' which include items such as the line screen used for printing; common sizes for magazine part-page advertisements and the amount of bleed or image overhang needed.

Web output

Images destined for the Web need a different profile (sRGB) from those commonly used by photographers (Adobe RGB (1998) or Pro Photo). The images will display at screen resolution and should be resampled to 72 pixels per inch at their native size. Continuous colour images can be saved in either JPEG or PNG formats. Although their use is getting less and less frequent, GIF images do not have continuous colour but feature 256 colours that best reproduce the image (an image of a red rose will store 256 reds and pinks for example).

Some fine art printing requires – for best quality output – that the files are sent to the printer at a resolution of 360 pixels per inch. Some photographic labs offering large format printing will supply printer profiles for you – ask if they are not offered as part of the service. If the supplier says you do not need a profile or does not understand the question, find another supplier.

Print output

For printing in books and magazines, it is usual to supply images that have a 5–95 per cent tonal range and not a 0–100 per cent range as the latter shows paper white holes and inky solid blacks instead of natural highlights and shadow detail. All these rules may seem arbitrary and obscure to the newcomer, but whatever the rules, the professional photographer has to find out and supply their work in an appropriate format.

Sharpening

It is recommended that digital files are sharpened two, possibly three times throughout the workflow. The first being capture sharpening, you can then apply sharpening creatively and finally you should apply output sharpening. Files destined for different outputs need to be sharpened in different ways – even at the same print resolution, for instance, an ink-jet print on gloss paper can show more detail than one produced on fine-art paper. To get the best results each file must be sharpened appropriately.

'Files destined for different outputs need to be sharpened in different ways.'

◀ Basic workflow: Optimisation for output
Basic workflow: Archiving
▶ Basic workflow: Cataloguing and digital asset management

Basic workflow: Archiving

As much of a professional photographer's future income will come from legacy images, it makes sense to take good care of all images, to archive them and to catalogue them in a form that allows easy retrieval. Lets look first at how images can be stored. Photographers shooting film will need to use conservation quality materials and archival storage for their negatives and transparencies. There was a time that stock libraries would only consider film images captured on Kodachrome as this was considered the only transparency material with any claim to being stable over a long period of time.

Colour slides made using E6 chemistry were not considered – for a long time – to be suitable for long-term storage, although modern film and processing has improved longevity considerably. Today, most film photographers would immediately scan their film originals, putting the original negatives and slides into safe long-term storage and deal only with the digital scan.

Online storage

So how do you store digital material? You need to protect against loss of data and loss of access to the media on which it is stored. Unlike a scratched negative, which can be repaired or retouched, digital data once 'damaged' is lost forever. The only thing is to keep plenty of copies of digital files in more than one location.

Online storage is becoming a popular solution – this puts your files in storage on remote servers. The only real risk to the images is the financial stability of the companies offering these services. Any photographer entering a contract would be wise to look at the insurance values for lost material and the possibility of compensation claims.

DVDs and CDs

The generally accepted 'archival' storage solution has been DVDs or CDs, with the major recommendation that read-only disks are used and that CD-R, CD-RW and all re-writeable DVD formats are not suitable for long-term storage.

Although it was heralded as a storage medium for the very long term, the CD has not proved to have anything like an archival life-span (with the exception of some of the archival quality 'gold' disks). None of the magneto-optical and removable hard-drive systems popular in the 1980s have survived. This is a warning to the photographer of the need to keep copying their digital material on to the latest 'archival' media to avoid technological obsolescence.

What do you store?

Camera files – as Raw
or converted DNG

Make sure XMP sidecar files
are kept as they retain all the
Camera Raw settings

Edited files – as Photoshop
documents PSD

Keep full layer, mask
and comp information

Output files – as TIFFs or PDFs

Hard drives

External hard drives were once not considered
sufficiently reliable for long-term storage, but technology
has improved and many photographers now use hard
drives for online access to archival material. What tends
to make hard drives obsolete is the connection –
while SCSI was once the main computer connector,
it is now difficult to retrieve data from a SCSI hard drive.
Again, you have to keep copying your files on to the
latest media to avoid the trap of obsolescence.

File retention

You need to retain versions
of the same image from various
stages of the workflow. Original
camera files, any file that has
been edited and final output
files. At each stage consider
how much work you would
have to do to recreate any file
you consider throwing away.

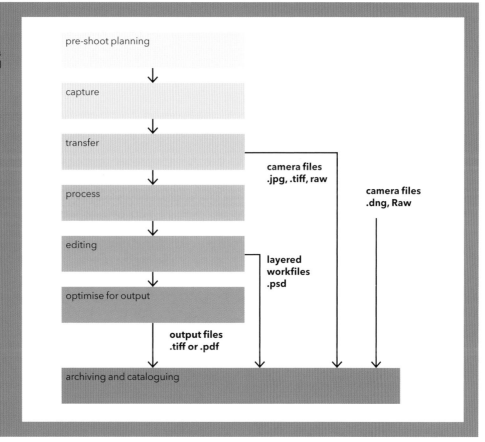

Basic workflow: Cataloguing and digital asset management

Cataloguing has already been mentioned in the context of editing and selection. Many photographers will use cataloguing software or digital asset management (DAM) software to 'see' their files through the whole process. While it was once a fairly easy task to hold a negative file sheet up to the light and identify the individual images, this is clearly impossible with digital files.

The file name may be limited by the computer operating system and it may not be possible to give images meaningful names such as 'Kathy and Alan's Wedding 2009 - bride and groom leaving after service'. You have no chance remembering that this is what image _DSC0345.NEF actually contains. A small copy of the image - a thumbnail or preview image - has to be available to identify the image.

Albums

One of the key ideas behind an album or collection of digital files is that the file does not physically have to reside in two places to appear in two albums. Pointers can be set so a picture of your grandmother and her dog can appear in a family album, an album of dog images and one featuring senior citizens. Each album will point back to the original file. How you catalogue depends on your need to retrieve images.

In the long term, it becomes vital to create accessible catalogues of legacy files that are keyword indexed and cross-referenced. Specific images can then be identified and retrieved from wherever they have been archived, for the images may not be stored online and accessible at all. They may be stored on CD or DVD or on another server or external hard drive that requires mounting. There is money to be made from legacy files, but the photographer must be able to retrieve them economically to make handling old images financially viable.

Digital asset management (DAM)

Digital asset management software handles more than image files and can produce catalogues of audio and video files, as well as illustration files in bitmap and vector forms, and also most document and page layout file formats. Some photographers simply suppress these cataloguing filters to use a digital asset manager as an image database. Leaders in the field of DAMs include Extensis Portfolio, Canto Cumulus, Microsoft Expressions Media (which was once iView MediaPro) and ACDSee. You may need to become familiar with the general ideas of indexing, key-wording and cataloguing, as you may be expected to use one or more of these programs depending on your place of work.

Although it was developed from the File Browsing feature of Adobe Photoshop version 6.0, you can forget Adobe Bridge for cataloguing, as it is a cache not a database. It rapidly became the management application for Adobe's Creative Suite of illustration, design, page and web layout products and shows the current state of play on your hard drives and mounted disks – it does not keep track of off-line images as does true cataloguing software.

'It becomes vital to create accessible catalogues of legacy files that are keyword indexed and cross-referenced.'

◀ Basic workflow: Cataloguing and digital asset management
Impact of digital
▶ Workflow products

The impact of digital

The impact of digital on the professional photography market has been immense. Many clients wrongly thought digital meant 'free' in the sense that once you'd bought the kit there were no on-costs for film or processing. At one time a pro could expect a yearly film and processing bill in the region of tens of thousands of dollars – so surely all that money saved can be passed on to the client in lower charges? What is never taken into account by this argument is the cost of digital capital equipment and the short life over which its costs must be amortised.

A professional film camera could easily earn a living on the 'front line' for ten years and probably give another 10-15 years' service as a second body or back-up. A state-of-the-art digital professional camera may be physically built to last as well but the technology is advancing so rapidly that it effectively becomes obsolete the day it is bought. D-SLR cameras seem to last two to three years in professional hands. The market for so-called medium-format digital has had to embrace the possibility of manufacturer exchange or modular upgradeability to provide some solution to the twin problems of slower technological improvements from smaller specialist companies and the major cost of these cameras.

Cost has also limited access to some of the finest digital cameras and has reduced the opportunity for students to get first-hand experience of working with state-of-the-art equipment.

'Cost implications need careful explaining and a true and fair charge made.'

Obsolescence and upgrading

Some colleges and universities have not been able to keep up with the increasing costs and shorter market lives of digital cameras. Some digital camera manufacturers and distributors have run part-exchange deals with professionals in a rolling programme of product replacement.

The pro is credited for the cost of the old camera, gets new kit and the old camera goes to a college. It is not only the kit on offer today at colleges, but also what plans there are to upgrade it and keep up with the game. For both professional photographers and educational establishments, the additional costs of computing power and software upgrades are also crippling.

Computers share the same two-to-three-year obsolescence cycle; imaging software seems to have an 18-month upgrade cycle. Nor can the cycle of product replacement and computer upgrade be readily broken as buying a new digital camera often means its files can only be conveniently opened with the latest version of a raw processor, which demands the latest processor to run. Camera, computer and software all need upgrading together.

Digital costs need covering as clients are benefiting from the conveniences and workflow changes digital has brought. In fact, the digital imaging revolution has front-loaded the job workflow and pushed a lot of responsibility for producing finished print-ready images on to the photographer. Photographers should never be tempted to solve the issue of digital costs by shooting a pile of images and dumping them on to a CD; letting the client sort them out. It may seem like there is no effort in producing a digital contact sheet as opposed to processing a film for contacting, but there are skill and equipment costs involved. These cost implications need carefully explaining and a true and fair charge made for all digital processing.

Workflow products

A new generation of computer software has been designed to address the needs of the professional photographer. Products such as Adobe Photoshop Lightroom and Apple Aperture take the photographic workflow as the starting point for their design. These products are built around powerful Raw processors but stop short of real content editing. However, they could readily form the software basis of a professional photographer's business without the need for other image-editing or cataloguing products – at least in theory.

Most professionals employ a very personal selection of programs, often not using the full feature set of any one piece of software. They often prefer to mix and match to suit their own workflow preferences and photographic style. In the past, many photographers based their professional workflow around Adobe Photoshop. Photoshop is the industry standard product for image editing – though that is precisely where its strengths lie: as a layered image editor.

Image browsing

Photoshop only fairly recently was updated with any type of file browser at all, to enable users to find and preview images before editing. The Adobe File Browser feature of old has now been transformed into a fully-fledged asset manager called Adobe Bridge. However, Bridge does not offer cataloguing as we have already seen. The user interface for workflow products such as Aperture and Lightroom is centred around a catalogue of images.

Aperture initially held all images in one giant library, but this approach was criticised by users and both it and Lightroom now catalogue files through the existing operating system hierarchy. The developers of workflow products recognise the fact that photographers shoot a lot of images and then whittle down the selection to just the best one or two on both technical and artistic grounds.

Getting images into use

Once the handful of good images has been selected – more often than not this is being done on a tethered camera system with the computer in the studio – the Raw file processor is put to work to enhance and non-destructively edit the images. The user interface has been designed around the ideas and practices of the photographer, who in all probability is not a computer or image editing specialist.

Some editing features that once required that the file be exported to an external editor – thereby degrading image quality – can now be done non-destructively within the workflow program. The second generations of both Aperture and Lightroom have seen this kind of development, with effects such as graduated filtering and local selective adjustments becoming possible.

Getting images into use is the final stage of the workflow. Aperture and Lightroom have powerful print and output capabilities that make it possible to create websites, sophisticated presentations, book projects, fine-art prints and make uploads to social networking and gallery sites without difficulty. Workflow products are designed to support third-party plug-ins to extend their functionality and to offer solutions for specific professional requirements, such as online portfolio content management or portrait retouching. We are only just at the beginning of the development curve of workflow products.

‘Most professionals often prefer to mix and match to suit their own workflow preferences and photographic style.’

Conclusion

A joke recently doing the rounds of the photographic community featured the punch line: 'the difference between a large-size pepperoni pizza and a photojournalist is that a large-size pepperoni pizza can feed a family of four'. This comically but equally tragically underlines the increasing difficulty in generating a living wage from active photography. The editor of the *British Journal of Photography* caused outrage recently among college staff by suggesting that their graduates 'have virtually no prospect of making a living from it (photography)'. Employment statistics suggest only a small proportion of graduates will find full-time employment in photography. And the adoption of digital imaging technology has only made things worse.

So why study photography at all? Although only a few will make it to the very top, that is no barrier to stop you trying to be one of them. Your degree can be looked on as 'money in the bank' to be spent in the future. Photography degree courses should not be seen as training for employment, but as an education in what has become one of the most powerful cultural forces. Because you cannot find full-time employment as a photographer does not mean you cannot make part of your living in photography. Portfolio employment, where the individual balances income from a variety of jobs and contracts, is going to be a much more common form of employment in the future. The tenured post or pensioned and salaried job will not be the norm for the next generation.

You therefore need to find a new way of surviving and thriving in a photographic landscape that has dramatically changed in terms of technology and employment in a very short time. You will need excellent technical skills in photography - and some competencies in related fields like writing, web design, retouching or cataloguing. As a photographer working in the creative industries, you cannot rely solely on technique. In no time someone will work it out, then copy or better what you have been doing. You need to learn to see and photograph in a unique and personal way - to create something that cannot be copied. This is what a formal education helps develop for all but that lucky and talented few.

Above all you need creativity and freshness. Creativity is like your health – it suffers without proper food and regular exercise. A full-time education will almost above all else show you how to research for ideas, how to develop, refine and express those ideas in your own work. To know how far you will go in creative photography, answer just one question honestly: how much do you want it?

Painted
Michelle Wood

Developing both your technical
skills and a personal style is the
key to survival and success in the
creative imaging industries.

Glossary

Alternative processes
Historic or commercially abandoned ways of creating imagery used by fine art photographers or hobby specialists. Many based on imaging chemistry other than traditional silver halide. Examples would be Vandyke brown, the bromoil process, cyanotypes, salt prints, the collodion, wet-plate process – you can readily discover 40 or more.

Aperture
Variable opening in the lens controlling the intensity of light reaching the film or sensor.

Auto-focus
Automatic system in cameras to obtain and maintain a sharply focused image without manual intervention.

Colour gamut
Range of colours a device can produce, or a colour model represent.

Colour spaces
Three-dimensional representations of the colours that can be reproduced by a colour model.

Composite image
Image, usually computer generated, that combines elements from two or more sources. Sometime done to deceive.

Composition
Giving form by putting together or combining various elements.

Conceptual
Based on concepts, ideas or a general notion.

Context
Circumstances surrounding an event or image that help make its meaning clear – examples are social, personal, historical or political contexts.

Digital photography
Photographic images created by regular sampling where brightness or colour is stored in numerical code as binary numbers.

Ethics
Set of principles concerning right and wrong, good and bad.

Events photography
Recording of a planned public or social occasion and the people who attend.

File format
Specific way information is encoded or stored on a computer.

Genre
Category of artistic work.

Graphics
Visual arts, usually clustered around illustration and drawn representation but stopping short of photography.

Greyscale
Image containing only information about brightness or intensity and not colour – another word for black-and-white image.

Intent
Purpose behind something (an image).

Key
Mood of an image (usually used of portraits) expressed in the tonal balance. High-key images are composed largely of light tones; low-key composed largely of dark tones, but both have full tonal range and are not the same as over- or underexposed images.

Light meter
Device used to measure the intensity of light for photography, expressed as a combination of shutter speed and aperture or single Exposure Value (EV) number for given film speed or digital sensitivity. Measures either the incident light or the light reflected from the subject. Some additionally measure light from photographic flash.

Manipulation
Change content of an image (usually on computer) with filters, cloning (copying) parts of the image or by creating a composite image. A step beyond technical correction or enhancement.

Medium format digital
High-quality digital cameras based on medium format film camera systems, usually featuring a replaceable digital 'back' fitting in place of a film back.

Medium format/large format
6x6, 6x6.45, 6x7, 6x8, 6x9 cm formats on 120/220 roll film – sheet film in 5x4, 5x7, 10x8 inch formats and larger, capable of recording the finest detail.

Model and property releases
Legal agreements giving a photographer rights to use and publish an image of a person or building.

Perceptual
Relating to something that can be sensed.

Photojournalism
Communication of news primarily through images rather than the spoken or written word.

Photosensitive
Substance or device that reacts
to visible light (sometimes also
to light above and below the
visible spectrum UV and IR).

Plug-ins
Pieces of software code
that expand the capabilities
of a computer program.

Portfolio
Collection of images displaying
the skills and creativity of the
photographer to potential
clients; the case that contains
this work.

Post-production work
General term covering all work
done after the photographic
image has been created.

Profiling
Create a measure
of the colour accuracy
and capabilities of a display,
a capture or printing device.

Public relations agency
Organisation specialising
in the creation and maintenance
of a good public image
for a company or institution.

Reciprocity
The inverse relationship
between the intensity
of light and its duration reacting
with photosensitive materials
to create an exposure.

Separations
Files or films separated
into channels of data
corresponding to the primary
colours (in printing: cyan,
magenta, yellow and black)
used in the preparation
of printed colour images.

Sheet film/roll film
Individual pieces of
photographic film or a length
of flexible film wound with
a lightproof paper backing
used in large- and medium-
format cameras respectively.

Shutter speed
Time for which the film
or sensor is exposed
when a picture is taken.

Social photography
Photography of people,
includes wedding photography
and portraiture.

Stereoscopic
Any technique capable of
recording the three-dimensional
qualities (depth and volume)
of an object.

Symmetrical and asymmetrical
Having the same or
corresponding form
on either side of a central
dividing line or balanced
proportions. Lacking this
symmetry or balance.

Tethered camera
Digital camera, usually used
in a studio, that is connected
by cable to a computer,
which is then controlled
from the computer keyboard
and its imagery judged
on the attached monitor.

Toy cameras
Generic name for inexpensive
film cameras initially intended
as disposable, novelty
or inexpensive items but used
by fine art and commercial
photographers to create
a specific 'unprofessional' look.
Film from these cameras often
cross-processed in the 'wrong'
chemistry to enhance effect.

White balance
Adjusting for the colour
temperature of the illuminating
light, so white and neutral
colours appear truly neutral
and do not show a colour cast.

Bibliography and webography

Photographic and cultural history

Clarke, Graham. *The Photograph: A Visual and Cultural History*. Oxford Paperbacks (Oxford History of Art), 1997.

Hirsch, Robert. *Seizing the Light – a History of Photography*. McGraw Hill, 2000.

Jeffrey, Ian (Ed). *The Photography Book (The Photo Book)*. Phaidon Press, 2000.

Koetzle, Hans-Michael. *Photo Icons: The Story Behind the Pictures*. Volume 1, Volume 2. Taschen, 2002.

Marien, Mary Warner. *Photography: A Cultural History*. Laurence King, 2002.

Orvell, Miles. *American Photography*. Oxford Paperbacks (Oxford History of Art), 2003.

Stepan, Peter (Ed). *Icons of Photography: The 20th Century*. Presetel, 2005.

(*Photo Icons* and *Icons of Photography* cover some of the same ground)

Art

Bright, Susan. *Art Photography Now*. Thames & Hudson, 2006.

Cotton, Charlotte. *The Photograph as Contemporary Art*. Thames & Hudson, 2004.

Jaeger, Anne-Celine. *Image Makers, Image Takers*. Thames & Hudson, 2007.

Präkel, David. *Basics Photography: Composition*. AVA Publishing, 2006.

Technique

Hicks, Roger; (and others). *Photographing People: Portraits Fashion Glamour*. Rotovision, 2001.

Langford, Michael; (Anna Fox and Richard Sawdon Smith). *Langford's Basic Photography*. Eighth Edition. Focal Press, 2007.

Prakel, David. *Basics Photography: Lighting*. AVA Publishing, 2007.

General

Berger, John. *Ways of Seeing*. Penguin, 1990.

Dyer, Geoff. *The Ongoing Moment*. Vintage, 2007.

Dyer, Gillian. *Advertising as Communication*. Routledge, 1988.

Kobre, Kenneth. *Photojournalism, Sixth Edition: The Professionals' Approach*. Focal Press, 2008.

Präkel, David. *The Visual Dictionary of Photography*. AVA Publishing, 2009.

Shore, Stephen. *The Nature of Photographs*. Phaidon Press, 2007.

Beyond the Lens: Rights, Ethics and Business Practice in Professional Photography. Association of Photographers, 2003.

Though some readers may expect to find key works of philosophical commentary by Barthes and by Sontag, I would recommend these text be left for the first year of a university course in photography. Instead, I would personally recommend a book like *The Ongoing Moment* by Geoff Dyer as a way to ignite a passion for photography.

Photographers whose work you must see

Any list is contentious and can be a source of disagreement. This one is meant to include an important representative cross-section of the work of artists and photographers whose images have made a key contribution to photographic culture and seem, in my experience, to have a particular appeal and accessibility to those starting out in photography.

Berenice Abbott – Ansel Adams – Diane Arbus – Eugéne Atget – Richard Avedon – David Bailey – Bernd and Hilla Becher – Guy Bourdin – Margaret Bourke-White – Brassaï – Sophie Calle – Henri Cartier-Bresson – William Christenberry – Larry Clark – Geoffrey Crewdson – Louis-Jacques Mandé Daguerre – Philip-Lorca diCorcia – Rineke Dijkstra – Robert Doisneau – William Eggleston – Peter-Henry Emerson – Walker Evans – Andreas Feininger – Roger Fenton – Joan Fontcuberta – William Henri Fox Talbot – Robert Frank – Lee Friedlander – Nan Goldin – Andreas Gursky – David Hockney – Horst P Horst – Yousuf Karsh – André Kertész – Nick Knight – David LaChapelle – Dorothea Lange – David Levinthal – László Moholy-Nagy – Man Ray – Sally Mann – Robert Mapplethorpe – Mary Ellen Mark – Don McCullin – Ralph Eugene Meatyard – Joel Meyerowitz – Duane Michals – Lee Miller – Lisette Model – Eadweard Muybridge – James Nachtwey – Martin Parr – Irving Penn – Rankin – Oscar Gustav Rejlander – Albert Renger-Patzsch – Jacob Riis – Sebastião Salgado – Cindy Sherman – Sandy Skoglund – W Eugene Smith – Edward Steichen – Alfred Stieglitz – Paul Strand – Thomas Struth – Hiroshi Sugimoto – Mario Testino – Wolfgang Tillmans – Arthur Tress – Andy Warhol – Weegee – Edward Weston – Garry Winogrand – Joel-Peter Witkin

Museums, exhibitions, galleries and collections

One of the most important things you can do is to look at original prints whether in permanent collections or travelling exhibitions. Most major cities have a unique photographic collection – although some websites are listed here, the best way to discover these caches is to go to: **www.photography-now.com**

Webography

The web is by it nature a fluid and ever changing place. The moment you list a URL it is often discontinued or move to another address. It is hoped that most of these sites – having already survived in cyberspace for some period – will continue to do so for the foreseeable future. Apologies for any that don't make it into your present.

www.alternativephotography.com
The 'art, processes and techniques' of alternative photography.

www.artsmia.org/animal-locomotion
Eadweard Muybridge images in animations.

www.cambridgeincolour.com
Some of the best photography tutorials in terms of presentation and content.

www.digitaltruth.com
Ironic title for the home of the giant film development chart.

www.eastmanhouse.org
George Eastman House International Museum of Photography and Film.

www.filemagazine.com
Online magazine and collection of unexpected photography.

www.icp.org
International Center of Photography, New York.

www.lensculture.com
Online magazine of international contemporary photography, art, media, and world cultures.

www.masters-of-photography.com
Great resource and stepping-off point, but some major names are missing – do not steal your college essays from here, your tutors will know!

www.media.gn.apc.org/photo/index.html
London Freelance branch of National Union of Journalists – information for photography on the law and rates of pay.

www.moma.org/explore/collection/photography
NY Museum of Modern Art (MoMA) collection of photography.

www.photoethnography.com
Site by Karen Nakamura (Assistant Professor of Anthropology at Yale University) about the 'art and science of representing other cultures visually'.

www.photography-now.com
International online platform for Photography and Video Art' exhibitions, festivals, museums.

www.photonotes.org
Accurately describes itself as 'a free public information resource for the Internet photographic community'.

www.photowings.org
A vehicle for bringing together people from divergent perspectives who share an interest in photography.

www.redeye.org.uk
UK based photography network with vital resources for aspiring professionals.

www.socialdocumentary.net
Photography that investigates 'critical issues facing our world today'.

www.vam.ac.uk/collections/photography/index.html
London's Victoria and Albert Museum's collection of photography.

Index

Acknowledgements and picture credits

Thanks to photo-writer Mike Johnston of The Online Photographer (www. theonlinephotographer.com) for permission to quote his advice on portfolios and to Sarah Dixon, Marketing Manager for Contract Store (www.contractstore.com), who gave permission to reuse their model release form in this book.

Thanks are due to Roger Fuller for his helpful comments on design. Thank you also to past students: Caroline Leeming, Alina Tait , Anna Griffiths, Andy Clarke, Colin Demain and Andrew Conner Tyrell for materials. Thanks also to Deborah Parkin for discussions about photographic vocabulary and to Mike England, course leader MA and BA Photography at the University of Cumbria.

Index compiled by
Indexing Specialists (UK) Ltd,
Indexing House,
306A Portland Road,
Hove,
East Sussex
BN3 6LP.
Tel: 01273 416777.
email: indexers@indexing.co.uk
Website: www.indexing.co.uk

Special thanks are due to Helen Stone, Production Assistant, who worked tirelessly with me on picture research, and to my editor Renee Last. Also a special thank you to David Dennison, Curriculum Manager, School of Art & Design and students at Blackpool and The Fylde College for taking some pictures especially for publication.

As always a special thank you to my wife Alison for her support and for always finding the time to proofread and comment so helpfully on my manuscripts.

David Präkel

Working with ethics
**The Fundamentals
of Creative
Photography**

Ethical: aware-
ness/
reflect-
ion/
debate

Publisher's note

The subject of ethics is not new, yet its consideration within the applied visual arts is perhaps not as prevalent as it might be. Our aim here is to help a new generation of students, educators and practitioners find a methodology for structuring their thoughts and reflections in this vital area.

AVA Publishing hopes that these **Working with ethics** pages provide a platform for consideration and a flexible method for incorporating ethical concerns in the work of educators, students and professionals. Our approach consists of four parts:

The **introduction** is intended to be an accessible snapshot of the ethical landscape, both in terms of historical development and current dominant themes.

The **framework** positions ethical consideration into four areas and poses questions about the practical implications that might occur. Marking your response to each of these questions on the scale shown will allow your reactions to be further explored by comparison.

The **case study** sets out a real project and then poses some ethical questions for further consideration. This is a focus point for a debate rather than a critical analysis so there are no predetermined right or wrong answers.

A selection of **further reading** for you to consider areas of particular interest in more detail.

Introduction

Ethics is a complex subject that interlaces the idea of responsibilities to society with a wide range of considerations relevant to the character and happiness of the individual. It concerns virtues of compassion, loyalty and strength, but also of confidence, imagination, humour and optimism. As introduced in ancient Greek philosophy, the fundamental ethical question is: *what should I do?* How we might pursue a 'good' life not only raises moral concerns about the effects of our actions on others, but also personal concerns about our own integrity.

In modern times the most important and controversial questions in ethics have been the moral ones. With growing populations and improvements in mobility and communications, it is not surprising that considerations about how to structure our lives together on the planet should come to the forefront. For visual artists and communicators, it should be no surprise that these considerations will enter into the creative process.

Some ethical considerations are already enshrined in government laws and regulations or in professional codes of conduct. For example, plagiarism and breaches of confidentiality can be punishable offences. Legislation in various nations makes it unlawful to exclude people with disabilities from accessing information or spaces. The trade of ivory as a material has been banned in many countries. In these cases, a clear line has been drawn under what is unacceptable.

But most ethical matters remain open to debate, among experts and lay-people alike, and in the end we have to make our own choices on the basis of our own guiding principles or values. Is it more ethical to work for a charity than for a commercial company? Is it unethical to create something that others find ugly or offensive?

Specific questions such as these may lead to other questions that are more abstract. For example, is it only effects on humans (and what they care about) that are important, or might effects on the natural world require attention too?

Is promoting ethical consequences justified even when it requires ethical sacrifices along the way? Must there be a single unifying theory of ethics (such as the Utilitarian thesis that the right course of action is always the one that leads to the greatest happiness of the greatest number), or might there always be many different ethical values that pull a person in various directions?

As we enter into ethical debate and engage with these dilemmas on a personal and professional level, we may change our views or change our view of others. The real test though is whether, as we reflect on these matters, we change the way we act as well as the way we think. Socrates, the 'father' of philosophy, proposed that people will naturally do 'good' if they know what is right. But this point might only lead us to yet another question: *how do we know what is right?*

You

What are your ethical beliefs?

Central to everything you do will be your attitude to people and issues around you. For some people, their ethics are an active part of the decisions they make every day as a consumer, a voter or a working professional. Others may think about ethics very little and yet this does not automatically make them unethical. Personal beliefs, lifestyle, politics, nationality, religion, gender, class or education can all influence your ethical viewpoint.

Using the scale, where would you place yourself? What do you take into account to make your decision? Compare results with your friends or colleagues.

Your client

What are your terms?

Working relationships are central to whether ethics can be embedded into a project, and your conduct on a day-to-day basis is a demonstration of your professional ethics. The decision with the biggest impact is whom you choose to work with in the first place. Cigarette companies or arms traders are often-cited examples when talking about where a line might be drawn, but rarely are real situations so extreme. At what point might you turn down a project on ethical grounds and how much does the reality of having to earn a living affect your ability to choose?

Using the scale, where would you place a project? How does this compare to your personal ethical level?

01 02 03 04 05 06 07 08 09 10

01 02 03 04 05 06 07 08 09 10

Your specifications
What are the impacts of your materials?

In relatively recent times, we are learning that many natural materials are in short supply. At the same time, we are increasingly aware that some man-made materials can have harmful, long-term effects on people or the planet. How much do you know about the materials that you use? Do you know where they come from, how far they travel and under what conditions they are obtained? When your creation is no longer needed, will it be easy and safe to recycle? Will it disappear without a trace? Are these considerations your responsibility or are they out of your hands?

Using the scale, mark how ethical your material choices are.

Your creation
What is the purpose of your work?

Between you, your colleagues and an agreed brief, what will your creation achieve? What purpose will it have in society and will it make a positive contribution? Should your work result in more than commercial success or industry awards? Might your creation help save lives, educate, protect or inspire? Form and function are two established aspects of judging a creation, but there is little consensus on the obligations of visual artists and communicators toward society, or the role they might have in solving social or environmental problems. If you want recognition for being the creator, how responsible are you for what you create and where might that responsibility end?

Using the scale, mark how ethical the purpose of your work is.

01 02 03 04 05 06 07 08 09 10

01 02 03 04 05 06 07 08 09 10

One aspect of photography that raises an ethical dilemma is that of inherent truth or untruth in manipulating images, particularly with the use of digital cameras. Photographs have, arguably, always been manipulated and at best they represent the subjective view of the photographer in one moment of time. There has always been darkroom manipulation through retouching or double exposures, but these effects are far easier to produce digitally and harder to detect. In the past, the negative was physical evidence of the original, but digital cameras don't leave similar tracks.

While creative photography might not set out to capture and portray images with the same intent that documentary photography might, is there an inherent deception in making food look tastier, people appear better looking or resorts look more spacious and attractive? Does commercial image manipulation of this kind set out to favour the content in order to please, or is it contrary to public interest if it results in a purchase based on a photograph that was never 'the real thing'? How much responsibility should a photographer have when the more real alternative might not sell?

Bernarr Macfadden's *New York Evening Graphic* was dubbed 'the Porno Graphic' for its emphasis on sex, gossip and crime news. In the early 1920s, Macfadden had set out to break new ground and publish a newspaper that would speak the language of the average person. One of the paper's trademark features was the creation and use of the composograph. These were often scandalous photographic images that were made using retouched photo collages doctored to imply real situations. The most notorious use of the composograph was for the sensational Rhinelander divorce trial in 1925.

Wealthy New York socialite Leonard Kip Rhinelander married Alice Jones, a nursemaid and laundress he had fallen in love with. When word got out, it was one of high society's most shocking public scandals in generations. Not only was Alice a common maid, it was also revealed that her father was African American. After six weeks of pressure from his family, Rhinelander sued for divorce on the grounds that his wife had hidden her mixed-race origins from him. During the trial, Jones's attorney had requested that she strip to the waist as proof that her husband had clearly known all along that she was black.

Because the court had barred photographers from witnessing this display, the *Evening Graphic* staged a composograph of Jones displaying her nude torso to the all-white jury. It was made by combining separate photographs of all the people involved and resizing them to proportion. Harry Grogin, the assistant art director, also arranged for an actress to be photographed semi naked in a pose that he imagined Alice would have taken. Grogin is said to have used 20 separate photos to arrive at the one compiled shot, but the resulting picture was believable. The *Evening Graphic's* circulation rose from 60,000 to several hundred thousand after that issue.

Despite healthy sales, the paper struggled financially because its trashy reputation did not attract advertisers. In spite of the financial position, Macfadden continued to plough his own money into the venture. The paper lasted just eight years – from 1924 to 1932 – and Macfadden is said to have lost over USD$10 million in the process. But the sensationalism, nudity and inventive methods of reporting set a model for tabloid journalism as we know it today.

Is producing fake images of real situations unethical?

Is it unethical to produce images based on sensationalism and nudity?

Would you have created composographs for the *Evening Graphic*?

A photograph is a secret about a secret. The more it tells you the less you know.

Diane Arbus

Further reading

AIGA
Design Business and Ethics
2007, AIGA

Eaton, Marcia Muelder
Aesthetics and the Good Life 1989,
Associated University Press

Ellison, David
*Ethics and Aesthetics in European Modernist Literature:
From the Sublime to the Uncanny*
2001, Cambridge University Press

Fenner, David E W (Ed)
Ethics and the Arts: An Anthology
1995, Garland Reference Library of Social Science

Gini, Al and Marcoux, Alexei M
Case Studies in Business Ethics
2005, Prentice Hall

McDonough, William and Braungart, Michael
Cradle to Cradle: Remaking the Way We Make Things
2002, North Point Press

Papanek, Victor
Design for the Real World: Making to Measure
1972, Thames & Hudson

United Nations Global Compact
The Ten Principles
www.unglobalcompact.org/AboutTheGC/TheTenPrinciples/index.html